MINDGAME

Anthony Horowitz
MINDGAME

OBERON BOOKS
LONDON

WWW.OBERONBOOKS.COM

First published in 2000 by Oberon Books Ltd.
521 Caledonian Road, London N7 9RH
Tel: +44 (0) 20 7607 3637 / Fax: +44 (0) 20 7607 3629
e-mail: info@oberonbooks.com
www.oberonbooks.com

Reprinted in 2006, 2011, 2013, 2016

A catalogue record for this book is available from the British Library.

PB ISBN: 9781840021738
E ISBN: 9781849436519

Cover image / design by Dan Steward
eBook conversion by CPI Group (UK) Ltd, Croydon, CR0 4YY.

Characters

STYLER

FARQUHAR

PAISLEY

Mindgame was first performed at the Mercury Theatre, Colchester on 2 September 1999, with the following cast:

STYLER, Christopher Timothy
FARQUHAR, Simon Ward
PAISLEY, Susan Penhaligon

Director, Richard Baron
Designer, Ken Harrison
Lighting, Mark Pritchard

The production subsequently transferred to the Vaudeville Theatre, London on 5 June 2000, with the following cast:

STYLER, Christopher Blake
FARQUHAR, Simon Ward
PAISLEY, Helen Hobson

Director, Richard Baron
Designer, Ken Harrison
Lighting, Mark Pritchard
Producers, Julius Green and Ian Lenagan

ACT ONE

The office of DR ALEX FARQUHAR at Fairfields, an experimental hospital for the criminally insane. The décor is modern, clinical – yet somehow disconcerting. A mirror on one wall. A window with no particular view.

On the desk: a telephone and a prominent alarm button. A Marks and Spencer bag that will be found to contain a box of tissues.

In the room: bookshelves full of books, a vase of sunflowers, an empty bottle of red wine. A medical screen. A wastepaper basket. A human skeleton on a stand. One door opens into a closet. Another into a bathroom. A third into the outside corridor.

Note: In MINDGAME, nothing exists until it is said to exist. It is whatever the protagonists make of it.

Sitting in a chair in front of the desk is MARK STYLER, a writer aged about fifty, casually dressed. Self-confident to the point of being smug. His face is pale and his haircut a little odd but otherwise he's the archetypal expert we've seen wheeled onto many a TV documentary. He has a worn leather briefcase.

He's been kept waiting. He looks at his watch for the tenth time. He gets up and examines the room. The skeleton. Looks at his watch again.

A pause.

He takes a tape recorder out of his pocket and switches it on.

STYLER: Recording. Six fifteen, Thursday July 22nd.

Pause.

First impressions of Fairfields. Note to myself…why that name? The view from Dr Farker's office. A nineteenth century manor house set in its own extensive grounds in this secluded corner of Suffolk…if indeed that most ill-defined of English counties could be said to have corners. The walls that surround the place may be predictable but the attendant ivy and – I think – Japanese wisteria are surely not. As I drive up the perfectly manicured lawns with rockery to the right and lily pond to the left, it is only the click of the maximum security metal doors

automatically closing behind me and the synchronised whirr of a dozen closed circuit TV cameras turning to follow me that remind me that I am not a guest at some exclusive Home Counties health resort but a writer, privileged to be invited into the country's most notorious asylum for the criminally insane.

Pause

Query. Why sick bastards locked up at the tax payers' expense should enjoy perfectly manicured lawns, lily ponds etc. Nice thought about the health resort.

Pause

What does the office of Dr Farker tell me about the man who runs Fairfields? Clinical. Hard-edged. Uncomfortable. Odd detail...the skeleton. A complete human skeleton standing in the corner. Did Dr Farker once study medicine – anatomy? In the office of a psychiatrist it seems oddly disconcerting but then maybe that's the idea. To disconcert. To keep you off balance.

Pause

Books predictable. *(Reading a spine.)* Group Psychotherapy. Sociometry and Psychodrama. *(Continuing along the shelf.)* Miller. Milner. Mishler. Morino. Dr Farker arranges his books alphabetically. I wonder if I can trust him? *(He picks up the wine bottle.)* One empty bottle of Chateau Mavillion 1966. *(Pause.)* Chateau Mavillion 1966. It feels as if it's been placed here like a prop for me to find. It's a little ludicrous, like the skeleton.

Pause.

There's not very much in this room that's personal, and nothing at all that connects it with the world outside unless you count the telephone and what I take to be a panic button. I wonder if Dr Farker sleeps on the premises? Sitting here in this office, walled in by his own A-to-Z of analysis, he's probably as out-of-touch as the inmates and he's kept me waiting here two hours, the rude bastard.

STYLER turns off the tape and puts it back in his case. He sits down again. He looks at his watch. A pause. He goes over to one of the doors and tries it. It's locked. He goes over to the other door...the same. He tries it again, rattling the handle.

And now it's the first door that suddenly opens and DR ALEX FARQUHAR comes in. Also aged about fifty, FARQHAR is a strange blend of the saturnine and the benevolent, as if Sherlock Holmes and Watson had somehow been blended into one. Penetrating, investigative eyes that have a habit of not focusing on what they're looking at. Wind-swept hair. A louche quality.

STYLER is a little embarrassed to have been caught, trying the door.

FARQUHAR: Good evening.

STYLER: Dr Farker?

FARQUHAR: It's actually Farrer. The q is silent and the h is redundant but anyway I prefer Alex. Please, take a seat.

STYLER: Thank you.

FARQUHAR: I'm sorry I've kept you waiting. We had a little trouble in B-wing. Nothing serious but it still demanded my attention.

STYLER: That's all right. It was very good of you to agree to see me.

FARQUHAR: That's my pleasure. Think nothing of it. Please...

FARQUHAR gestures at a chair as he moves behind the desk. STYLER sits opposite him. FARQUHAR gazes at him curiously for a moment.

FARQUHAR: Look, this is very embarrassing but I'm afraid you're going to have to tell me exactly what it is I agreed to see you for. The fact is that my secretary is on holiday and what with one thing and another my paperwork has rather got on top of me. I know it's unforgivable but the truth of the matter is that as I stand here before you, I don't have the faintest idea who you are.

STYLER: You don't?

FARQUHAR: None at all.

STYLER: I'm Mark Styler.

FARQUHAR: That's your name?

STYLER: Yes.

FARQUHAR: And what is this in connection with?

STYLER: I wrote a letter...almost a month ago. Your secretary didn't mention it to you before she left?

FARQUHAR: I'm afraid not. But then she's been gone a long time. To be frank, I'm often tempted to get rid of her. To let her go. The way she just ups and disappears like this. But she has excellent shorthand and typing skills and as I'm sure you'll understand, good secretarial help is extremely hard to come by, particularly in this neck of the woods.

STYLER: You mean an insane asylum.

FARQUHAR: I was referring to Suffolk generally. You say you wrote to her.

STYLER: I wrote to you. And you replied. At least, I assumed it was you. The letter was signed in your name.

FARQUHAR: It certainly wasn't me. I'm very sorry but I have absolutely no recollection of it. Mark Styler, you say? The name does sound familiar to me. Are you a doctor?

STYLER: No. I'm a writer. You don't know my work...?

FARQUHAR: I'm sure I should. I do apologise, Mr Smiler.

STYLER: Styler. Mark...

FARQUHAR: It's unlike me to be so...disorganized. Perhaps we should start from the beginning. I feel I should almost walk out of the room and come in again.

STYLER: Not with another two-hour wait.

FARQUHAR: You were kept waiting that long?

STYLER: Well...

FARQUHAR: You must be angry.

STYLER: I'm just glad you agreed to see me.

FARQUHAR: Any minute now we're going to establish what it was I agreed to see you about. *(He rummages in the desk.)* If I could just find this letter of yours…

STYLER: Perhaps this will help.

STYLER reaches into his briefcase and takes out a sheet of paper (in fact blank).

FARQUHAR: And what is this?

STYLER: It's a copy of my letter.

FARQUHAR: A copy of the letter you sent me almost a month ago?

STYLER: Yes.

FARQUHAR: Excellent. That really is first rate.

FARQUHAR takes the letter and tries to focus on it.

FARQUHAR: Ah yes. Yes. *(He puts the letter down.)* Actually, I seem to have mislaid my reading glasses so why don't you just take me through the gist of what it says?

STYLER: You can't read it?

FARQUHAR: Not without my reading glasses.

STYLER: *(Surprised but continuing anyway.)* Well, it's quite simple really.

FARQUHAR: You're a writer.

STYLER: Yes. You know, Dr Farquhar, I'm quite surprised you haven't read any of my books.

FARQUHAR: Should I have?

STYLER: I wrote a book about Chikatilo…

FARQUHAR: Andrei Chikatilo?

STYLER: Yes. It was called 'Serial Chiller: The True Story of a Monster in the Ukraine.' It was something of a best-seller.

FARQUHAR: And don't tell me. You've come here because you want to write a book about one of the residents here.

STYLER: Yes.

FARQUHAR: Did you mention that in your letter?

STYLER: Well, obviously. It's right here.

FARQUHAR: And I invited you here to see me? I'm afraid there must have been some sort of misunderstanding. I couldn't possibly allow you access.

STYLER: Isn't that a little…autocratic?

FARQUHAR: No. It's entirely autocratic. But you see, I am the master of Fairfields. And what I say, goes.

STYLER: So you keep your patients locked up, isolated. What's the point in that?

FARQUHAR: There would be no point if that were the case. But I can assure you we do much, much more than that.

STYLER: Tell me.

FARQUHAR: Why?

STYLER: Because I'm interested.

FARQUHAR: No. I think you should leave/

STYLER: I've driven three and a half hours to get here, Dr Farquhar…

FARQUHAR: Three and a half hours? *(Pause.)* From London?

STYLER: Yes. *(Pointing at the window.)* Mine is the red BMW near the main door. I got lost outside Framlingham.

FARQUHAR: We're nowhere near Framlingham.

STYLER: That's how I knew we were lost. Would it be possible to have a cup of tea before I go?

FARQUHAR: *(Impatient.)* Mr Styler…

STYLER: I drove three and a half hours without passing a single café. There was nothing. And I've been sitting here in your office…

FARQUHAR: There's a Happy Eater on the A12.

STYLER: Happy Eater? They went out of business years ago.

FARQUHAR: There's one just outside Colchester.

STYLER: I didn't see it.

FARQUHAR: I was there yesterday.

STYLER: Well it wasn't there today.

FARQUHAR: A cup of tea.

STYLER: If it's not too much trouble.

FARQUHAR hesitates. Then picks up the telephone and punches a number.

FARQUHAR: *(On the telephone.)* Nurse Paisley. Could you come up please? *(He hangs up.)* There…

STYLER: Paisley?

FARQUHAR: Yes.

STYLER: Is that her name?

FARQUHAR: Yes. Why do you ask?

STYLER: Well I knew a Paisley once – and she was also a nurse. That's quite a coincidence.

FARQUHAR: She can take you through to the kitchen and get you a cup of tea.

STYLER: Thank you.

FARQUHAR: On your way out.

STYLER: Right. *(Pause.)* You were about to tell me about Fairfields.

FARQUHAR: Was I?

STYLER: You were going to tell me what you do here. I was wondering about the name.

FARQUHAR: Well of course we changed the name when I first came here. It used to be called the East Suffolk Maximum Security Hospital for the Criminally Insane.

STYLER: I suppose Fairfields is less threatening.

FARQUHAR: Do you?

STYLER: Well, isn't it?

FARQUHAR: I've never really thought about it. I suppose so, now you mention it.

STYLER: How many inmates do you have here?

FARQUHAR: Actually, I'm not very partial to the word 'inmates'. It smacks too much of the judiciary. True, our patients have been sentenced by the courts and are here for life. They have no hope of release or remission. But what drives Fairfields – our philosophy, if you like – is that the very worst examples of humanity, what the tabloids and writers like yourself call monsters, still have some hope of redemption and reparation. That a lifetime incarcerated need not be a lifetime entirely wasted. I'm a great believer in the work of Ronny Laing. R.D. Laing. And as he put it: 'Madness need not be all breakdown. It can also be breakthrough.'

STYLER: So how many patients do you have.

FARQUHAR: At the last count there were fifteen.

STYLER: Are they all dangerous?

FARQUHAR: Not all of them. No. Two of them are well into their eighties and don't really remember who or where they are. As for the rest…I'm sure you know perfectly well. Fairfields houses the serial killers. Society's bogey men. The monsters who've murdered their wives and their children. Who have tortured and raped and killed. Who have committed atrocities so appalling that even the tabloids have had to show some deference, tiptoeing around the truth. We are a Chamber of Horrors… according to the *Daily Mail* anyway, and they should know.

STYLER: I have to say, I didn't see a lot of security coming in here.

FARQUHAR: Did that make you nervous?

STYLER: No. There was one thing though.

FARQUHAR: Go on.

STYLER: The man at the gate. The guard.

FARQUHAR: Yes?

STYLER: Well, I don't want to be cruel, but there did seem to be something wrong with him. I mean, he was disfigured.

FARQUHAR: Ah – that must have been Borson.

STYLER: He was quite badly disfigured – his face. He must have had some sort of accident.

FARQUHAR: Yes. It happened when he was a child. He never talks about it but I'd hate to think that you believe it disqualifies him for the job.

STYLER: No. Not at all. It's just that he didn't ask me for ID or anything. I could have been anyone. And if as you say the institution is meant to be maximum security...

FARQUHAR: It is.

STYLER: ...well, to be honest with you, once I'd got through the gate, I felt more as if I was coming into a country hotel than a...

FARQUHAR: ...lunatic asylum.

STYLER: Yes.

A speaker clicks into life and suddenly the room is filled with soft, syrupy music. This music will click on and off at random throughout the play.

FARQUHAR: It wasn't what you were expecting.

STYLER: That's right. *(Pause.)* What horrible music, if you don't mind my saying so.

FARQUHAR: I don't. I agree with you. But the patients like it...although I will admit that we've been having a few problems with the speaker system.

STYLER: *(Joking.)* Don't tell me you can't turn it off!

FARQUHAR: It turns itself off. And on, unfortunately. It was damaged a couple of weeks ago...quite a nuisance, really. We'd get someone in but it's a Swedish system... Anyway, you were saying. More like a country hotel than a lunatic asylum.

STYLER: Yes.

FARQUHAR: It's a common misconception. The very word 'asylum' has come to mean something that's grim and forbidding. Gothic towers and huge, creaking doors. People have forgotten that prisons and asylums are two quite different things. The former are to lock people in. The latter are to protect people by keeping the world out.

STYLER: You don't want to feel like an institution.

FARQUHAR: Exactly.

STYLER: So why the terminology? You were talking about B-wing.

FARQUHAR: There are three wings. Bee, Honey and Flower. They were given the names by Karel Ennis who founded Fairfields and who personally raised the money to landscape the grounds.

STYLER: It doesn't disguise the fact that the patients here are still prisoners.

FARQUHAR: It's not intended to. But I'm not here to keep prisoners. My job is to set them free.

STYLER: Not literally, I hope.

FARQUHAR: From themselves. "To enlighten the endless night of insanity with the torch of responsibility." That's Michel Foucault.

STYLER: And you do that by giving them a nice garden?

FARQUHAR: *(Annoyed.)* I can't explain it to you.

He picks up the telephone and punches the button again.

FARQUHAR: *(On phone.)* Nurse Paisley? *(Pause.)* Yes. Yes. Yes. We're still waiting.

He puts the phone down.

STYLER: I'm sorry. How do you set them free from themselves?

FARQUHAR can't decide if it's worth continuing. But he gives STYLER another chance.

FARQUHAR: Well, in broad strokes, we start by putting back the lines, the human connections that were absent for far too long in mental hospitals such as this. I want my patients to feel at ease so that in their sessions with me, at least part of the psychiatrist-patient relationship will be broken down. I want to meet them as equals.

STYLER takes this as his cue to sit in FARQUHAR's chair – on his side of the desk – for the first time.

STYLER: And what then?

FARQUHAR: That very much depends on the patient. Dr Ennis was a great believer in psychodrama.

STYLER: I'm sorry?

FARQUHAR: He studied under JL Moreno in Vienna.

STYLER: Moreno?

FARQUHAR: Yes. He was the director of the Theatre of Spontaneity.

STYLER: You make me feel I should know about him.

FARQUHAR: You should. Moreno was inspired by watching children at play in his garden in Vienna. This was in about 1920. He began to see that play, and play-acting, could be used as a therapeutic process and that's what Karel Ennis brought here.

STYLER: He wrote plays.

FARQUHAR: No, no. He was interested in spontaneity-creativity. Role-playing. He encouraged his patients to take the parts of their parents, their children, their wives or whatever and by playing out these often disturbed relationships to arrive at the cause of their emotional distress. Of course, I'm simplifying what was actually a very precise and highly structured process. Anyway, Ennis took the mechanics of psychodrama one step further by

applying them to psychotics – alas, with only limited success.

STYLER: Why only limited?

FARQUHAR: Because in the end one of them turned round and killed him. That was when I took over.

STYLER: Do you still use psychodrama?

FARQUHAR: I'm more selective about the patients I apply it to and I have to say that one of the first things I did when I inherited this office was to have a decent alarm installed. *(He points to the button on his desk.)* But yes, I'm trying to continue the work that Ennis began.

A sudden, terrible scream from outside; the demented blood-chilling howl of a wild man. Loud enough to startle the audience. STYLER springs up. Bizarrely, FARQUHAR appears not to have noticed it.

STYLER: What the hell was that?

FARQUHAR: What?

STYLER: Didn't you hear it?

FARQUHAR: I'm sorry?

STYLER: It came from outside.

STYLER goes over to the window and looks out.

FARQUHAR: There's no one outside.

STYLER: But I heard them.

FARQUHAR: It came from B-Wing. This is Wednesday night. They have scream therapy.

STYLER: It's not Wednesday. It's Thursday.

FARQUHAR: No. It's the 21ˢᵗ. Wednesday.

STYLER: Are you sure?

FARQUHAR: I'm quite certain.

STYLER: *(Turning from the window.)* Do you mind if I smoke?

FARQUHAR: My dear fellow, your personal habits are entirely your own concern.

STYLER: No. I mean – do you mind if I smoke now?

FARQUHAR: You want a cigarette.

STYLER: Yes.

FARQUHAR: Please. Go ahead.

STYLER: Thank you.

STYLER takes out a crumpled packet of ten Embassy cigarettes. He takes one out, puts the packet on the desk, then searches his pockets.

STYLER: That's strange.

FARQUHAR: What?

STYLER: I seem to have forgotten my lighter.

FARQUHAR: No lighter?

STYLER: I'm sure I put it in my pocket this morning.

FARQUHAR: When you left London.

STYLER: Yes.

FARQUHAR: You have your cigarettes?

STYLER: Yes. But I've forgotten my lighter. You wouldn't have a match?

FARQUHAR: I'm afraid I don't smoke.

STYLER: Aaah…

FARQUHAR: And as a security measure, I don't keep matches in the office. Maybe Nurse Paisley will have some when she arrives. *(Annoyed.)* Where is Nurse Paisley?

STYLER: Dr Farquhar, why won't you at least consider what I have to say?

FARQUHAR: About your book?

STYLER: Yes. Obviously, I've only skimmed the surface, compared to you. I'm a populist and I'm not ashamed to admit it. But even so, if you read my books, you might surprise yourself. You might even be impressed by their honesty if nothing else.

FARQUHAR: You wrote about Chikatilo.

STYLER: Yes. And after that I wrote another book which covered nine more serial killers including Nilsen, Sutcliffe, Shipman, Fred and Rosemary West and Dahmer.

FARQUHAR: What was it called?

STYLER: 'Bloodbath. Inside the Minds of Nine Serial Killers.'

FARQUHAR: And did you get there? Inside the minds?

STYLER: I did my research.

FARQUHAR: There is one thing I'd be interested to know, Mr Styler. Why do you write these books? What's your interest in these people?

STYLER: Well, I suppose I'm trying to illustrate one aspect of the human condition; the relationship between good and evil. That's what it really comes down to. The fact that humans are capable of acts of extreme evil as well as extreme good.

FARQUHAR: Saints or sinners.

STYLER: Exactly.

FARQUHAR: But taken to extremes.

STYLER: It's only natural for a writer to be interested in extremes because that's where the essence of human nature will be in sharpest focus.

FARQUHAR: So why didn't you choose saints? *(Pause.)* 'Bloodbank. Inside the Minds of Nine NHS Nurses'.

STYLER: Well. I suppose sin sells better.

FARQUHAR: And this next book of yours…

STYLER: It's going to be very big. I have a publisher, a very reputable house. They've been talking to the *Sunday Times* and we may have a serialization. The Americans are interested…in fact the publishers were queuing up at Frankfurt. All this on a five-page outline. Come on, Dr Farquhar! Six one-hour interviews. That's all I ask. I'll let you have the questions in advance and you can be in the room from start to end.

FARQUHAR: Perhaps you should try again in a year or so's time. As it happens, I'm planning to leave Fairfields.

STYLER: You're retiring?

FARQUHAR: I'm leaving. Quite soon, as a matter of fact. I want to travel. I could be going any day now. Maybe you can approach my successor.

STYLER: No. It has to be now. We're coming up to the thirtieth anniversary of Easterman's arrest. It's event publishing. The book, the serialization, perhaps even a Channel 4 tie-in. It couldn't be a better time.

FARQUHAR: Easterman?

STYLER: What?

FARQUHAR: You want to write a book about Easterman?

STYLER: Didn't I say?

FARQUHAR: No. You didn't.

STYLER: I'm sorry. I should have said right away. That's the book I want to write. I want to write about Easterman.

A pause. FARQUHAR seems almost shocked. And then the door opens and NURSE PAISLEY comes in. In her late forties, spinsterish, prematurely grey. A serious, even a severe woman. Making a bad job of disguising the fact that she is extremely nervous.

FARQUHAR: Aaah – Nurse Paisley, at last!

PAISLEY: What do you want?

FARQUHAR: We have a guest.

PAISLEY: I know. I can see that.

FARQUHAR: You're not being very friendly.

PAISLEY: I'm busy.

FARQUHAR: His name is Mark Styler. He's a writer.

PAISLEY: I know his work.

STYLER: Do you?

PAISLEY: I read your book about Andrei Chikatilo. What was it called? 'Serial Chiller'.

STYLER: I'm flattered.

PAISLEY: I didn't enjoy it.

STYLER: Oh.

PAISLEY: I thought it was gruesome.

FARQUHAR: Mr Styler wants to write a book about Easterman.

PAISLEY: Easterman?

FARQUHAR: Yes.

PAISLEY: *(To STYLER.)* He won't talk to you. You're wasting your time. Anyway, it's against the policy of the hospital. You ought to go. Now. *(To FARQUHAR.)* Do you want me to show him out?

STYLER: I think that was the general idea.

FARQUHAR: Mr Styler wanted a cigarette.

PAISLEY: I don't have any cigarettes. I don't smoke.

FARQUHAR: He has his own cigarettes.

PAISLEY: Then why was he asking?

FARQUHAR: He doesn't have a light.

STYLER: That's right. I seem to have forgotten my lighter.

PAISLEY: There's a lighter in the desk.

FARQUHAR: Is there?

PAISLEY: The second drawer down. On the left.

FARQUHAR is surprised. He opens the drawer.

FARQUHAR: You're absolutely right. I'd forgotten.

PAISLEY: It's always there.

FARQUHAR: I can see that. It's unlikely to stray. Does it have gas?

PAISLEY: No. It's a petrol lighter.

FARQUHAR: *(Annoyed.)* Does it have petrol?

PAISLEY: I expect so. There's a spare can in the drawer.

FARQUHAR takes out a small petrol can, glances at it and puts it back.

FARQUHAR: You're right. *(To STYLER.)* Then you can have your cigarette.

STYLER takes out his cigarette. FARQUHAR takes out the lighter and moves towards him. But the cigarette lighter is on a chain and reaches only half way across the room.

FARQUHAR: It seems you're going to have to meet me half way.

STYLER: Security?

FARQUHAR: Yes.

STYLER: With respect, Dr Farquhar, I wouldn't have thought it was something you'd forget. A thing like that.

FARQUHAR: I've had a lot on my mind.

STYLER steps forward. FARQUHAR lights the cigarette for him.

STYLER: Thank you.

PAISLEY: I'll show you to the main gate.

FARQUHAR: Actually, I think I might give Mr Styler a little more of my time.

STYLER: Really?

PAISLEY: Why?

FARQUHAR: I'd be interested to know why, of all the people here, he chose Easterman for his next oeuvre.

PAISLEY: But you're not going to let him write it.

FARQUHAR: Anything is possible. I hadn't realised he was such a major literary figure.

STYLER: Well…

PAISLEY: He isn't.

FARQUHAR: He has a publishing deal with a reputable firm. A possible serialization in the *Sunday Times*.

PAISLEY: Dr Farqhuar…

FARQUHAR: We actually called you up here because he's hungry.

PAISLEY: That's not my business.

FARQUHAR: I know. But I was wondering if you could talk to Cookie.

PAISLEY: Cookie?

FARQUHAR: In the kitchen. I was hoping they might be able to rustle something up.

STYLER: I don't want to be a nuisance.

FARQUHAR: No. You've driven three and a half hours to get here. You didn't pass a single Happy Eater. I kept you waiting. It's the least I can do.

PAISLEY: But the kitchen's closed.

FARQUHAR: Already?

PAISLEY: Cookie's gone home.

FARQUHAR: It's very early.

PAISLEY: She wasn't well.

FARQUHAR: She never told me.

PAISLEY: You were busy. *(To STYLER.)* You could go to the pub. There's a pub just a mile down the road. The Miller's Arms. They do a very good shepherd's pie.

FARQUHAR: Mr Styler doesn't want a shepherd's pie. He just wants a cup of tea and a sandwich.

STYLER: Just a cup of tea will be fine.

FARQUHAR: Surely to goodness we can rustle up a sandwich for a guest who's driven three and a half hours to get here.

A pause. PAISLEY realizes she has no choice.

PAISLEY: What sort of sandwich?

FARQUHAR: Mr Styler?

STYLER: Anything really…

FARQUHAR: There you are then. *(To PAISLEY.)* Ham. Cheese and pickle. Tuna and cucumber. Egg and cress. Peanut butter and strawberry jelly. Anything you can lay your hands on.

PAISLEY: What if there's no bread?

FARQUHAR: Of course there's bread. There's always bread.

PAISLEY: There may not be.

FARQUHAR: Then give him some Ryvita.

Again, PAISLEY can see she's not going to win the argument.

PAISLEY: I suppose I can look.

FARQUHAR: Just bring him a sandwich with anything you can find.

PAISLEY: Right.

FARQUHAR: And a cup of tea.

PAISLEY: I'll see what I can do.

FARQUHAR: That's very kind of you.

A dismissal. But PAISLEY doesn't leave.

FARQUHAR: Yes?

PAISLEY: He needs an ashtray.

FARQUHAR: What?

PAISLEY: Mr Styler's cigarette. He needs an ashtray.

STYLER: Thank you.

FARQUHAR: *(Irritated.)* Nurse Paisley…

PAISLEY: He's going to get ash on the carpet.

FARQUHAR: I don't have an ashtray.

PAISLEY: There's one in the desk. Third drawer down.

FARQUHAR: On the left or the right?

PAISLEY: The right.

FARQUHAR: You seem very familiar with the contents of my desk, Nurse Paisley.

PAISLEY: Yes. I try to be.

FARQUHAR: Third drawer down.

PAISLEY: On the right.

FARQUHAR leans behind the desk. At that moment, PAISLEY's whole manner changes. She produces a folded note and urgently waves it at STYLER. He responds with puzzlement and is about to come over and take it when FARQUHAR suddenly looks up, suspicious.

FARQUHAR: I can't find it.

PAISLEY: It should be there.

FARQUHAR: But it isn't.

PAISLEY: Did you move it?

FARQUHAR: I never even saw it.

PAISLEY: Perhaps it went into the second drawer.

FARQUHAR: On the right?

PAISLEY: On the left.

FARQUHAR leans down again and at that moment, PAISLEY slips the note to STYLER who hides it. But right then FARQUHAR pops up again, this time holding the ashtray. He is immediately suspicious.

FARQUHAR: Nurse Paisley?

PAISLEY: Yes, Dr Farquhar?

FARQUHAR: Is there something I should know?

PAISLEY: No, Dr Farquhar.

A pause. DR FARQUHAR is still suspicious.

FARQUHAR: A sandwich and a cup of tea.

PAISLEY: Right away, Dr Farquhar.

PAISLEY glances one last time at STYLER, trying to warn him with her eyes. Then she goes. FARQUHAR hands over the ashtray.

FARQUHAR: A souvenir of Torquay.

STYLER: Torquay?

FARQUHAR: Yes. Although the strange thing is, I can't remember ever going there. Is it possibly to have a souvenir of somewhere you've never been?

STYLER: I couldn't say.

FARQUHAR: Have you ever visited Torquay, Mr Styler?

STYLER: No.

FARQUHAR: You're not trying to hide something from me, are you?

STYLER: I've never been to Torquay.

FARQUHAR: I'm talking about Nurse Paisley. *(Pause.)* Just between you and me, Mr Styler, that woman's begun to worry me. That's the trouble with working with the criminally insane. Your perception gets twisted. You have no sense of what's real any more. No sense of anything. Maybe it's time she considered another career. What do you think?

STYLER: I don't know.

FARQUHAR: Why don't you tell me what's in that note she gave you?

STYLER: What note?

FARQUHAR: She gave you a note.

STYLER: She seemed to be afraid of you.

FARQUHAR: She's afraid of everything. Heights. Insects. The dark. Her own shadow. The note, please…

STYLER: Are you saying she's sick?

FARQUHAR: I'm saying she's overworked. *(Pause.)* Mr Styler, I'm trying to co-operate with you. But I can assure you that unless you give me that note, the note that Nurse Paisley gave you after she so clumsily diverted my attention with that ashtray, your book contract and your serialization and your Channel 4 television series will have less chance of realization than an afternoon of strip poker with the Archbishop of Canterbury.

A long pause. STYLER produces the folded note.

STYLER: She wanted me to read it.

FARQUHAR: And I don't.

STYLER: Why not?

FARQUHAR: Health and safety.

STYLER: Whose health? Whose safety?

FARQUHAR: Please.

STYLER hands over the note.

FARQUHAR: Thank you.

STYLER: Are you going to read it?

FARQUHAR: Maybe.

STYLER: I'd be interested to know what it says.

FARQUHAR: It's almost certainly irrelevant.

STYLER: Even so...

FARQUHAR opens the note and quickly reads it. He smiles.

FARQUHAR: It was nothing. I was right.

STYLER: You read it?

FARQUHAR: Yes.

STYLER: Without your reading glasses?

FARQUHAR: She has large handwriting.

STYLER: So can I see it?

FARQUHAR: No.

FARQUHAR picks up the lighter and sets fire to the note. It burns in his hand.

STYLER: What are you doing?

FARQUHAR: What do you think?

STYLER: But why?

FARQUHAR: Call it an act of spontaneity. Spontaneous combustion.

STYLER: I don't understand you. I don't understand any of this.

FARQUHAR: Give it time.

STYLER: What did she write?

FARQUHAR: You really want to know?

STYLER: Yes.

FARQUHAR: She thought she knew you.

STYLER: What?

FARQUHAR: She thought you were someone else.

STYLER: I don't understand.

FARQUHAR: Nurse Paisley thought she recognised you as someone who in fact you aren't. She was accusing you of being an imposter.

STYLER: That's ridiculous.

FARQUHAR: Exactly. Which is why I've burned the note.

At that moment, there is an explosive alarm. A bell rings and lights flash on and off in the room. The alarm is so loud, it's shocking.

STYLER: What now?

FARQUHAR: I don't know.

With the alarms still screaming, FARQUHAR picks up the telephone on his desk and punches in a number.

FARQUHAR: *(Shouting into the telephone.)* This is Farquhar. Can you tell me what's happening? I said…can you tell me what's happened? *(Pause.)* It's a false alarm. Repeat! False alarm.

The bell stops.

FARQUHAR: *(Into the telephone.)* Thank you. My security clearance is twenty-nine. My labrador's name is Goldie.

STYLER: What was that all about?

FARQUHAR: Stupid of me.

STYLER: What?

FARQUHAR: Burning the paper. I forgot that we have a very sophisticated smoke detector installed here. It set off the alarm…

STYLER: Will the fire brigade come?

FARQUHAR: No. You heard me give the security clearance. My ID number and a seemingly irrelevant personal detail but one that only I would know. So now they know it's a false alarm. Let's talk about Easterman.

STYLER: Actually, you know, I'm beginning to feel a little uneasy. There's something about this place. It doesn't feel quite right.

FARQUHAR: I've treated you badly.

STYLER: Well…

FARQUHAR: I'm tired. I admit it. I was annoyed you were here. But now that you are here, why don't you tell me a little more about yourself, your work. Tell me about your books. Did you bring them with you?

STYLER: No.

FARQUHAR: A shame. But you were saying there were two of them. 'Bloodbath' and…

STYLER: 'Serial Chiller'. Actually, I wrote other books too.

FARQUHAR: Also true crime?

STYLER: No. My first two books were quite different. They were about my mother.

FARQUHAR: Should I read something into that?

STYLER: Only that I had a very happy childhood and that I admired her. My father died when I was quite young and I was an only child. I was brought up in Bath.

FARQUHAR: Wiltshire.

STYLER: Avon, actually. My mother died when I was twenty-one.

FARQUHAR: I'm sorry. Was it illness?

STYLER: *(Hesitant.)* No.

FARQUHAR: An accident, then?

STYLER: Yes. It was very sudden. But anyway, she'd always encouraged me to write. She had great faith in my abilities. So after she died, I decided to write about her.

FARQUHAR: A biography?

STYLER: Not exactly. She was a very ordinary person, not someone you could write a book about. But she was a wonderful cook. So I wrote a book called 'My Mother's Table' which was a collection of her favourite recipes interspersed with anecdotes about her life. It was a bit like 'The Country Diary of an Edwardian Lady'. I suppose you don't remember that.

FARQUHAR: Yes.

STYLER: You do.

FARQUHAR: I don't.

STYLER: Well, it was quite a success, so the publishers asked me to write a sequel. So I came up with 'My Mother's Garden' which was really the same thing again but this time about her garden…tips on how to get the best out of your flowers and shrubs. That sort of thing. My mother spent a lot of time in the garden. It was nice to remember her that way.

FARQUHAR: It seems you made quite a killing out of your mother.

STYLER: Both books did well, it's true.

FARQUHAR: And you were still living in the same house? In Bath?

STYLER: No. After she died, I moved to London. I got married and bought a house in Victoria. Near the station.

FARQUHAR: You're married?

STYLER: No. Never found the right woman.

FARQUHAR: Or she never found you. So from cookery and gardening to serial killers. That's an unusual progression – if progress is indeed the word. What happened?

STYLER: Chikatilo.

FARQUHAR: You read about him in the papers.

STYLER: Yes. He aroused my interest.

FARQUHAR: And what exactly was it that aroused you, Mr Styler? Was it murder? Torture? Or cannibalism? All three featured fairly prominently in his career.

STYLER: I was thinking about writing fiction.

FARQUHAR: There was nothing fictitious about Andrei Chikatilo. He kidnapped young people in the woods outside Rostov, sexually abused them, tortured them, killed them and then ate them. He had a liking for liver, as I recall. The human liver. Something he had in common with Easterman, incidentally. They were both what you might call happy eaters.

STYLER: Yes. *(Pause.)* It's like I say. I was interested in the idea of a serial killer in Russia. The police investigation. The killings adding up. I thought it had all the makings of a real airport blockbuster.

FARQUHAR: Do you visit a lot of airports?

STYLER: Not really. Anyway, I began to realize that there was no need to add fiction to what had happened. So I wrote it as True Crime and sold more copies than anything I'd ever written before.

FARQUHAR: But I still find myself wondering what sort of readers would interest themselves in a vile, sexually deranged schoolteacher from the Ukraine. Hormonally challenged teenagers perhaps? Or the sort of ghouls who like to watch multiple pile-ups on the M25.

STYLER: The book sold half a million copies. You think they were all ghouls and teenagers

FARQUHAR: It wouldn't surprise me.

STYLER: I think you're being a little...high-minded, if you don't mind my saying so, Dr Farquhar. Every writer from Chaucer to Milton and Shakespeare has been attracted to

evil. Think of Iago. Lucifer. Moriarty. Voldemort. We're
attracted by these figures because they're part of us. That's
the truth of it. They're the dark, unspoken part of our
own psyche and we need them because they help us live
something out, if only vicariously, and we thank them
for it. Look at Jack the Ripper. Every child in the world
grows up knowing about Jack the Ripper. Tourists come to
London just to go on Jack the Ripper walks. Do you know
how many books there have been about him? How many
films? There have even been Jack the Ripper musicals.
And yet this was a man who did monstrous, unspeakable
things to women. He was a nightmare…and yet, you
tell me this. Is Jack a hero or a villain? Is he your sinner
or your saint? Maybe the answer…maybe the answer is
that he's neither. Maybe he's something else, something
we don't quite understand. But I'll tell you this. It isn't
revulsion we feel when we hear his name even though it
should be. It isn't loathing. It's a sort of excitement.

FARQUHAR: Was it excitement you felt when you were writing
about Chikatilo?

STYLER: I suppose I would have liked to have met him. I
wrote to the Russian authorities but by the time anyone
even replied to my letter, they'd already shot him.

FARQUHAR: And now you want to meet Easterman.

STYLER: *(With a sense of foreboding.)* Is he really here? In this
building?

FARQUHAR: Yes.

STYLER: It's strange to think that he could be just a few meters
away from where we are now.

FARQUHAR: He could be closer.

STYLER: What does he look like?

FARQUHAR: You don't know?

STYLER: Not really. There were so few photographs.

FARQUHAR: Most of them were destroyed when he burned
down his house.

33

STYLER: I saw the court drawings.

FARQUHAR: They were very bad. And anyway that was a long time ago. *(Pause.)* He was twenty-three when he was brought here. For ten years, he wouldn't leave his cell, ten years without seeing the sun. Gradually, we managed to coax him out, into the grounds, into therapy, but it took another two or three years before he'd even agreed to speak.

STYLER: He was ashamed of what he'd done.

FARQUHAR: Not at all. I think he was just shy. As you rightly say, he's been here for the best part of thirty years. Half his life. He must be about the same age as me.

A pause.

FARQUHAR: You said you did your research.

STYLER: Of course.

FARQUHAR: I'd be interested to know what you found. Your take on Easterman.

STYLER: Why?

FARQUHAR: What are we, Mr Styler, but what other people perceive of us?

A pause.

STYLER: Easterman was every mother's dream of a perfect son. Healthy, good-looking, athletic, intelligent. He went to a local grammar school. The family lived in Avon.

FARQUHAR: In Bath.

STYLER: Yes. It's one of the reasons I'm interested.

FARQUHAR: Were they near you?

STYLER: They weren't far.

FARQUHAR: But you never met him.

STYLER: *(Hesitant.)* No. *(Pause.)* When he was sixteen, his father died.

FARQUHAR: He killed his father. On a wine-tasting holiday at the Chateau Mavillion in France.

STYLER: I thought his father died in a car accident.

FARQUHAR: Easterman was driving. It was quite deliberate.

STYLER: How can you be sure of that?

FARQUHAR: He ran over him twice.

STYLER: Well, however it happened, after the death of his father, Easterman lived with his mother, in Bath. According to the neighbours, he was a completely trouble-free teenager.

FARQUHAR: He killed the neighbours.

STYLER: He only killed one of them.

FARQUHAR: Ah yes. Mrs Barlow.

STYLER: Yes. That was her name. *(Pause.)* But you've jumped ahead of me. The bulk of his killings took place in the eighteen months between age twenty-one and his arrest at the age of twenty-three. He actually killed his mother on the morning of his twenty-first birthday.

FARQUHAR: That's right. When they found her head, it was still covered in gift-wrap.

STYLER: He buried her in the garden and went on living in the house. It makes you think a little of Hitchcock, doesn't it.

FARQUHAR: Not really.

STYLER: The Bates motel? His next victim was a hospital worker called Jane Paisley. *(Realising.)* Nurse Paisley! That's where I'd heard it before.

FARQUHAR: Where is Nurse Paisley? She seems to be taking a devil of a long time with your sandwich.

STYLER: She's not related.

FARQUHAR: I hardly think so.

STYLER: Anyway, he picked up a number of people – tourists, students, whatever. His modus operandi was to drug them and then to take them to an abandoned boat house near

the Avon canal. I don't suppose you want me to go into the details.

FARQUHAR: You're saving them for your book?

STYLER: Well, there was torture, rape, humiliation. Horrible things. He cut up the bodies when he'd finished with them. Some of them he took home in pieces and buried in the garden. Like many serial killers, he kept souvenirs. He also cannibalized some of the corpses. He liked to eat...

FARQUHAR: The liver.

STYLER: Yes. Things only came to a head when his neighbours started asking questions about the state of his lawn. It's hard to imagine what took them so long. By the end, his garden must have looked like an archaeological dig. Anyway, the neighbours must have asked one question too many because one night he attacked them, killing Mrs Barlow at number twenty-nine and mutilating the Bundies at thirty-three. Then he walked into Bath police station and gave himself up.

FARQUHAR: But not out of remorse.

STYLER: Remorse never came into it. He pleaded guilty. He was found unfit to stand trial and was sent here.

FARQUHAR: All of which is accurate, more or less, but still doesn't answer my original question.

STYLER: Which was?

FARQUHAR: Why did you choose him? For your book?

But before STYLER can answer, the door opens and PAISLEY comes in carrying a tray with a single sandwich, a tea-pot and a small jug of milk.

FARQUHAR: It looks like your dinner's finally arrived.

STYLER: Thank you.

FARQUHAR: *(To PAISLEY.)* What took you so long?

PAISLEY: There was no one in the kitchen.

FARQUHAR: You didn't see Cookie?

PAISLEY: I told you. Cookie's gone home.

FARQUHAR: Oh yes.

PAISLEY: I did the best I could. *(To STYLER.)* I thought you might have gone.

STYLER: No. I'm still here.

PAISLEY: I can see that. But I thought…

FARQUHAR: Mr Styler decided to stay for dinner.

STYLER: Yes.

FARQUHAR: So you managed to rustle something up on your own?

PAISLEY: No. Borson did it.

STYLER: Borson?

PAISLEY: Yes.

STYLER: I thought he was on security.

PAISLEY: He is. But he came into the kitchen while I was there and when I told him what Dr Farquhar wanted, he insisted on making the sandwich.

FARQUHAR: And what did Borson put in the sandwich?

PAISLEY: Liver.

A long pause.

STYLER: It's very kind of you. But I'll just have the tea.

FARQUHAR: You don't like liver?

STYLER: Not especially.

FARQUHAR: It must have been left over from lunch. Isn't that right, Nurse Paisley.

PAISLEY: I don't know.

FARQUHAR: Of course you do. How was Borson, by the way?

PAISLEY: He didn't say anything. I told him you wanted a sandwich for your guest and that was what he gave me.

FARQUHAR: *(To STYLER.)* Left-overs. You'll have to forgive us.

STYLER: I don't mind left-overs, really I don't. But I'm beginning to wonder if I shouldn't go back to my hotel. They're expecting me for dinner.

FARQUHAR: Which hotel is that?

STYLER: Actually, I'm staying at that pub you mentioned. The Miller's Arms.

PAISLEY: Did you tell them you were on the way? I mean, did they know you were coming here and that afterwards you'd be returning for the night?

STYLER: Yes.

FARQUHAR: Then we mustn't disappoint them. *(To PAISLEY.)* You'd better ring them and tell them Mr Styler will be spending the night here with us.

PAISLEY: But he wants to leave. Don't you, Mr Styler?

STYLER: Well, to be honest, I do feel a bit uncomfortable about spending the night in a place like this. Nothing personal…

PAISLEY: There you are.

STYLER: I'm booked in overnight. I could come back tomorrow.

FARQUHAR: I'm afraid I can't see you tomorrow.

STYLER: No?

FARQUHAR: I'm busy tomorrow.

PAISLEY: No you're not. All your morning appointments have been cancelled. *(To STYLER.)* Dr Farqhuar could see you tomorrow at nine o'clock.

FARQUHAR: Nurse Paisley. Don't you think you're taking your responsibilities a little far? I don't remember opening my appointments book to you.

PAISLEY: I'm just trying to be helpful, Dr Farquhar.

FARQUHAR: If you want to be helpful, you could go down to Easterman and see if he's awake.

PAISLEY: What?

STYLER: You're going to let me see him?

FARQUHAR: No. Not necessarily.

PAISLEY: You don't want to see him.

FARQUHAR: *(Annoyed.)* Nurse Paisley…

PAISLEY: Please, Mr Styler, listen to me. Easterman is a monster. He's not mad like the other patients here. He's evil. He knows what he does and he gets pleasure from it. Even here at Fairfields.

FARQUHAR: *(Threatening.)* Be careful what you say.

PAISLEY: You can't write a book about Easterman. He's different to all the others. You don't want to be in the same room as him. You don't want to be anywhere near him. Because he'll play with you…like the devil. And then he'll break you down. He'll destroy you.

FARQUHAR: Nurse Paisley you are pushing me perilously close towards disciplinary action. I suggest you leave my office now.

PAISLEY: Shall I take the sandwich?

FARQUHAR: Leave the sandwich.

PAISLEY: But he doesn't want it.

FARQUHAR: He wants it.

PAISLEY: He said not.

FARQUHAR: He's changed his mind.

A pause. PAISLEY takes one last despairing look at STYLER, then leaves the room.

FARQUHAR: Eat.

Not an invitation. A command. FARQUHAR slides the plate forward. STYLER picks up the sandwich, thinks for a moment. Dismisses the foolish thought that was going through his head and bites into the sandwich.

FARQUHAR: How is it?

STYLER: *(Mouth full.)* Good.

FARQUHAR: Not too dry?

STYLER: No.

FARQUHAR: Sometimes, when the meat comes out of the freezer, it can be a little dry.

FARQUHAR pours some tea.

FARQUHAR: Have some tea. It's Lapsang Souchong.

STYLER: Are you going to let me see Easterman?

FARQUHAR: No.

STYLER: What?

FARQUHAR: You still haven't persuaded me that there would be any point to it. Oh yes, you've done a certain amount of research. But what you've told me anyone could have found out in a half hour on the internet. Why Easterman? That's what I want to know. Why Easterman as opposed to Sprinz or Chaplin, Morganstone, Netley, Borson or any of the other patients here.

STYLER: Borson?

FARQUHAR: What?

STYLER: You said Borson... You said Borson was a patient here.

FARQUHAR: Yes. He murdered his entire family. He wrapped them up and put them in the post. Second class mail...that tells you something.

STYLER: But Borson was the name of the man at the gate. He was also in the kitchen.

FARQUHAR: That's a different Borson. It's quite a common name.

STYLER: I wouldn't have said that.

FARQUHAR: There are two Borsons. It's a coincidence.

STYLER: Another coincidence.

FARQUHAR: Just answer my question, Mr Styler. What's so different about Easterman? Why, of all people, does he

appeal to you? There's no going forward until you answer that.

STYLER: All right. *(Pause.)* Every serial killer I've ever studied has been screwed up as a child. Jeffrey Dahmer was ignored by his parents. So was Ted Bundy…

FARQUHAR: This is all very familiar.

STYLER: Yes. But that's why Easterman is different. He had a wonderful childhood. His father, despite what you say, was devoted to him. His mother adored him. Right up to the time when the killings began there isn't a hint of deviancy in Easterman's life.

FARQUHAR: Go on.

STYLER: It was Socrates, wasn't it, who said that nobody ever does wrong willingly…by which he meant that if they really knew what they were doing, they would choose not to. Well, Easterman finally proves him wrong.

FARQUHAR: You think so?

STYLER: That's the point of my book. It asks a simple but I think fascinating question. What was it that turned a golden boy into a revolting beast?

FARQUHAR: A beast.

FARQUHAR considers the word. He is deeply annoyed.

FARQUHAR: Is that really the best you can come up with?

STYLER: Let me meet him and maybe I'll do better.

FARQUHAR: And you really think that – what was it you asked for? – six one-hour sessions with Easterman and you'll be able to find out more than we have in the constant, intensive therapy of the past thirty years?

STYLER: I didn't say that.

FARQUHAR: *(Angry.)* No, Mr Styler. I think I've had enough of this.

STYLER: What?

FARQUHAR: You write about cookery and gardening. Then you manage to get a couple of gaudy paperbacks onto the True Crime shelves of your local W.H. Smith – and you think that makes you some kind of expert on psychotherapy?

STYLER: Dr Farquhar…

FARQUHAR: You know, Mr Styler, I recognised you for what you were from the moment you walked into my office. You're the expert who knows nothing. Mr Television. The man they turn to when they need an opinion on Newsnight or Panorama. Fifty quid and a G&T with Jeremy Paxman. Fred West hangs himself. Someone goes mad with a machete in an American school. Let's go over to Mark Styler who's ready with an instant opinion and a quote from Socrates. Nurse Paisley was right about you. You're a fake. I don't know why I've wasted so much time with you.

STYLER: Wait…

FARQUHAR: Go on. Get out of here. Go back to your hotel.

STYLER: Easterman killed my mother.

A pause.

FARQUHAR: What?

STYLER: That's why I want to write a book about him. That's why I want to understand him. He murdered my mother.

FARQUHAR: There were never any victims called Styler.

STYLER: She went back to her maiden name after my father died. Victoria Barlow. She was Easterman's neighbor. He killed her.

A long pause.

STYLER: I was away when it happened. I was a student. But that day I came home for a visit. The first thing I saw was the smoke. Easterman had set fire to his own house. But first he had gone into hers. I tried to go on. But they stopped me. They held me back…

FARQUHAR: *(Gently.)* Why didn't you tell me this before?

STYLER: Because... *(Pause.)* It was after what he did to my mother that I moved to London. My poor mother. The police asked me to identify the body – but there wasn't much left to identify...not after what he'd done to her.

FARQUHAR: And you wanted to meet him? Why? What were you going to do if you found yourself in the same room as him? Did you want to kill him?

STYLER: No. I wanted to understand him. That's all. I thought, if I wrote about him, I might be able to...

FARQUHAR: What?

STYLER: *(Surprising himself.)* ...forgive him.

FARQUHAR: Forgive him?

STYLER: Yes.

FARQUHAR: You really think you could do that?

STYLER: Yes.

A pause. FARQUHAR picks up the telephone, punches a number.

FARQUHAR: *(Into the telephone.)* Nurse Paisley. Could you come back, please?

STYLER: May I have another cigarette?

FARQUHAR: Help yourself.

STYLER takes out his crumpled ten-cigarette packet and opens it. He takes out a cigarette and lights it.

FARQUHAR: Is that better?

STYLER: Yes.

A pause. STYLER smokes.

FARQUHAR: If you were to meet Easterman...

STYLER: What?

FARQUHAR: You wouldn't be afraid of him?

STYLER: Afraid of him?

FARQUHAR: Yes.

STYLER: Should I be? Is he still dangerous?

FARQUHAR: He's unpredictable.

STYLER: Unpredictable.

FARQUHAR: Which can be very dangerous indeed.

STYLER: Well, you'll get some security…

FARQUHAR: Not at this time of night. Security will have gone home.

STYLER: What about Borson?

FARQUHAR: He's on the gate.

STYLER: Maybe I could meet Easterman in his cell.

FARQUHAR: Both of you in his cell?

STYLER: Him in his cell. Me outside.

FARQUHAR: It's sound-proofed. The walls are two-feet thick.

STYLER: Oh. *(Pause.)* Could you restrain him?

FARQUHAR: What do you mean?

STYLER: Well, couldn't you put him in a strait-jacket or something.

FARQUHAR: *(Frustrated.)* Mr Styler…

STYLER: What have I said now?

FARQUHAR: I thought I'd explained the philosophy of Fairfields to you. But now I wonder if you listened to a single word I said!

STYLER: I listened.

FARQUHAR: The whole purpose of this institution, the founding principal, was to get beyond the terror that has for so many years imprisoned the mentally ill.

STYLER: *(Helpless.)* But you said he was in a cell…that the walls were two-foot thick.

FARQUHAR: That was his choice. It is Easterman who is hiding from us.

STYLER: I don't understand.

FARQUHAR: Well maybe if you put yourself in a strait-jacket you'd begin to. In fact, that's not such a bad idea. Have you ever seen a strait-jacket, Mr Styler? Have you ever held one? Have you ever put one on?

STYLER: No. Of course not.

FARQUHAR: Then maybe it's time you were educated.

STYLER: Wait a minute…

FARQUHAR: Let me show you what I mean.

FARQUHAR goes over to the door and opens it. Behind, there's a closet filled with books, papers and medical equipment. He takes out a strait-jacket.

FARQUHAR: We keep this for purely historical reasons, you understand. A reminder of the way things used to be. Put it on.

STYLER: You've got to be kidding.

FARQUHAR: I'm completely serious.

STYLER: I'm not sure I want to.

FARQUHAR: Of course you don't want to. If you wanted to, there wouldn't be any point.

STYLER: No!

FARQUHAR: Is that your decision.

STYLER: I'm not putting on a strait-jacket.

FARQUHAR: Think of your book.

STYLER: It's got nothing to do with my book.

FARQUHAR: If you don't agree to this little demonstration, there will be no book.

A pause.

STYLER: You really think this will prove something?

Nothing from FARQUHAR. STYLER makes his decision. He takes the strait-jacket, holding it as if it's an alien object.

STYLER: I don't even know where to start.

FARQUHAR: I'll help you. Your arms go in here.

FARQUHAR continues as he puts the strait-jacket on STYLER.

FARQUHAR: There you are. The left first, then the right. That's it. You are, if you like, embracing the very nature of madness. What do you think it would tell you about yourself, wearing one of these?

STYLER: That you were mad.

FARQUHAR: *(Still fitting the jacket.)* That you were considered mad – it's not quite the same thing. The man who put it on you might believe that you were, in his opinion, mad. But it might occur to you, it might cross your mind that it was in fact the reverse that was true. You might believe that it was he who was mad and you who were perfectly sane.

STYLER: I don't understand the point that you're trying to make.

FARQUHAR: The point is, that once you're wearing one of these, it no longer makes any difference. You have abrogated control, or rather, control has been taken away from you. It not only confines you. It defines you. A man wearing a strait-jacket can only be one of two things. An unsuccessful escapologist or a madman. There...

FARQUHAR stands back. STYLER is in the strait-jacket.

FARQUHAR: How do you feel?

STYLER: Helpless. Can you please take it off.

FARQUHAR: OK. But first you have to prove you're sane.

STYLER: What?

FARQUHAR: Tell me that you're sane.

STYLER: I'm sane.

FARQUHAR: I don't believe you.

STYLER: OK. You've proved your point.

FARQUHAR: Carpet.

STYLER: I'm sorry?

FARQUHAR: Carpet. Envelope. Wallpaper. Cigarette. Jelly.

STYLER: I don't understand you.

FARQUHAR: You think I'm talking nonsense.

STYLER: Yes.

FARQUHAR: But how do you know it is not I who am talking common sense and you who are hearing nonsense? The strait-jacket puts the weight of the argument on my side.

STYLER: *(Struggling.)* Yes, yes, yes. I was wrong to suggest using it. I see that now – so please take it off.

FARQUHAR moves closer to STYLER and speaks gently.

FARQUHAR: *(Quoting.)* 'He does not think there is anything the matter with him because one of the things that is the matter with him is that he does not think that there is anything the matter with him.'

STYLER: There's nothing the matter with me. I'm beginning to wonder if there isn't something the matter with you. From the moment I arrived…this whole place.

FARQUHAR: *(Suddenly mad.)* It's a madhouse!

STYLER: Bloody hell!

FARQUHAR turns to the desk and picks up a scalpel. He advances with it menacingly. His character is rapidly changing.

FARQUHAR: Let's take it one step further.

STYLER: What are you doing with that?

FARQUHAR: Does it make you nervous?

STYLER: Of course it does. What do you think?

FARQUHAR: You're afraid.

STYLER: Look. Put it down and let me go. Why are you playing these games with me?

FARQUHAR: Games? Do you remember what Nurse Paisley said?

STYLER: What?

FARQUHAR: *(Imitating her.)* 'He'll play with you...like the devil. And then he'll break you down. He'll destroy you!'

STYLER: She was talking about Easterman.

FARQUHAR: *(Holding the scalpel.)* Let's play games with this.

STYLER: What are you going to do with it?

FARQUHAR: Well, since you so obliged me by slipping into that strait-jacket, I thought I'd begin by giving you a very memorable scar.

STYLER: What?

FARQUHAR: Your left cheek or your right cheek? I could give you the choice. If you ask me nicely.

STYLER: What do you...what are you talking about?

FARQUHAR: Alternatively, of course, I could flay you alive. I wonder what that would be like? Edward Gein manufactured waistcoats out of his victims inspiring three Hollywood movies – Psycho, The Texas Chainsaw Massacre and The Silence of the Lambs...actually five if you count the remakes and let's not forget The Texas Chainsaw Massacre Two although according to the critics it probably is better forgotten. Anyway, it all demonstrates exactly what you were talking about earlier. The enduring fascination we have with insanity.

STYLER: God!

FARQUHAR: Exactly. That's who I am right now, to you. I am God. I am Jesus Christ – the original Easter man. I have complete power over you. Power without responsibility. And there is nothing in the world that feels quite like it.

STYLER: Are you mad?

FARQUHAR: You're the one in the strait-jacket.

Then the door opens and PAISLEY comes in. She takes in the room – the scalpel, the strait-jacket – with one glance.

PAISLEY: What's happening?

FARQUHAR: Nurse Paisley. You're not needed now.

PAISLEY: What are you doing?

FARQUHAR: I said – you're not needed now!

STYLER: Please. Help me, for God's sake…

PAISLEY: *(To FARQUHAR.)* You can't do this.

FARQUHAR: He wanted to meet Easterman.

PAISLEY: Let him go.

FARQUHAR: He asked to meet Easterman.

STYLER: No…

FARQUHAR: He wanted to understand.

PAISLEY: He's had enough!

And with her final word, PAISLEY picks up the empty bottle of wine and smashes it across FARQUHAR's head. The glass shatters and he falls unconscious, dropping the scalpel. A pause. PAISLEY stares at him.

PAISLEY: I couldn't let him do it. I had to stop him.

STYLER: I don't understand. Please. What's happening.

PAISLEY: Jesus Christ…

STYLER: Please, Nurse Paisley.

PAISLEY: *(Angry.)* That's not my name. I'm not a nurse!

STYLER: Then who are you?

PAISLEY: I'm Carol Ennis.

PAISLEY is also changing. She is more serious, authoritative. She has lost some of her fear.

STYLER: Ennis?

PAISLEY: Dr Carol Ennis. I'm the psychotherapist at Fairfields.

STYLER: I don't understand. *(Looking at the unconscious man.)* Dr Farquhar…

PAISLEY: That's not Dr Farquhar.

STYLER: What?

PAISLEY: Haven't you guessed? Isn't it bloody obvious? That's Easterman!

STYLER: But... What...?

PAISLEY: That is Easterman.

STYLER: So what happened to Dr Farquhar?

PAISLEY comes over to STYLER and starts to undo the strait-jacket. Or tries to.

PAISLEY: We're going to have to get out of here. You have your car outside?

STYLER: Yes. It's by the main door.

PAISLEY: It happened three weeks ago. There was a psychodrama session in this very room. Easterman and Borson were here and Alex – Dr Farquhar – was supervising. I was next door, observing. *(She points.)* That's a two-way mirror. Anyway, the session got out of control. Easterman grabbed Dr Farquhar and half-strangled him. At the same time, Borson came after me.

STYLER: The lunatics taking over the asylum.

PAISLEY: If you want to reduce it to a B-movie cliché. But yes.

STYLER: What happened?

PAISLEY: They killed all the staff. Some faster than others. The ones they had a grudge against...well, you don't want to know. Easterman toyed with Dr Farquhar for a week and even when he died it wasn't over.

STYLER: What do you mean?

PAISLEY: Easterman had him boiled down and then re-assembled him. The bones.

STYLER turns and gazes at the skeleton.

STYLER: No!

PAISLEY: Yes. That's Dr Farquhar standing there, what's left of him.

STYLER: Oh my God!

PAISLEY: They've kept parts of him in the freezer. They're still eating him.

STYLER: What parts?

PAISLEY: Muscle tissue. His heart. His liver…

STYLER: *(Gagging.)* Oh God!

PAISLEY: What is it?

STYLER: The waste-bin!

PAISLEY: What?

STYLER: I'm going to be sick.

> *PAISLEY snatches up the dustbin and holds it for STYLER who forces himself back under control and isn't in fact sick.*

PAISLEY: I did try to warn you.

STYLER: Why didn't you just tell me, for God's sake?

PAISLEY: I tried to. I have you that note.

STYLER: He burned it.

PAISLEY: It set off the alarm.

STYLER: Yes.

PAISLEY: If I'd told you the truth, he'd never have let you leave. I did the best I could.

> *PAISLEY puts down the bin.*

PAISLEY: We don't have time for this. We have to go.

STYLER: *(Struggling.)* Can't you get this thing off me?

PAISLEY: The straps are too tight. *(Struggling with the straps.)* Why did you let him put it on you in the first place? What sort of idiot are you?

STYLER: I was trying to humour him. Maybe someone can help…

PAISLEY: There is no one. I'm the only one left alive. You have no idea what it's been like for the past three weeks. I've been terrified. I've been absolutely terrified!

STYLER: We'll get out. We'll leave together.

PAISLEY: You think it's as easy as that? They're everywhere. They control the whole asylum. And the gates. They're electronic. We can't open the gates...

STYLER: Can't we telephone?

PAISLEY: They cut the wires. *(Giving up with the strait-jacket.)* I can't get this off.

STYLER: He had a scalpel. You can use it to cut through the straps.

PAISLEY: I don't see it.

STYLER: He must have dropped it when you hit him. It's got to be somewhere. Please, Nurse Paisley...

PAISLEY: Dr Ennis.

STYLER: Yes.

PAISLEY finds the scalpel.

PAISLEY: Here it is. Here...

PAISLEY turns back towards STYLER but at that moment FARQUHAR's hand suddenly jerks upwards, grabbing hold of her wrist.

FARQUHAR: That's mine I think.

STYLER: *(A shout.)* No!

PAISLEY: Help me!

FARQUHAR stands up. He and PAISLEY are locked in a sort of terrible, frozen dance. He throws her back onto the desk and her body lands on the panic button. At once there's a repeat of the smoke alarm, bells ringing and lights flashing. The chintzy music has also started up again, adding a further nightmarish dimension to the events on stage.

STYLER: Let her go, you bastard. Let her go!

But FARQUHAR can barely hear STYLER who is still helpless, squirming in his strait-jacket. FARQUHAR forces the scalpel out of PAISLEY's hand, then throws her behind the medical screen.

FARQUHAR: This won't take a minute.

FARQUHAR takes the scalpel and goes over to PAISLEY. The lighting allows us to see their shadows behind the screen as FARQUHAR stabs her several times. The alarm rings. The lights flash. STYLER can do nothing but squirm and scream.

STYLER: Don't hurt her! Oh for Christ's sake! Help someone! Help!

A pause. FARQUHAR steps out from behind the screen, his mad eyes fixed on STYLER. The glistening scalpel is on his hand. He is soaked in blood.

He picks up the telephone, Punches a number and speaks.

FARQUHAR: My security clearance is thirty-one. My labrador's name is Goldie.

The alarm stops. FARQUHAR advances on a terrified STYLER.

FARQUHAR: Time to start work on Chapter Two.

Blackout.

ACT TWO

The second act picks up at the last moments of the first. The alarm is still ringing. NURSE PAISLEY (Carol Ennis) has just been killed. DR FARQUHAR (Easterman) is talking on the telephone.

But during the interval, many small changes have been made to the set – as well as the costumes of FARQUHAR and STYLER. It's like one of those 'spot the difference' puzzles. Everything looks the same. But the audience should have a disconcerting feeling that nothing is.

FARQUHAR: My security clearance is twenty-nine. My labrador's name is Blondie.

The lights stop flashing. The bells stop ringing.

FARQUHAR: It's time to start work on Chapter Two.

STYLER: *(Total panic.)* Jesus Christ. Oh Jesus…

STYLER, impeded by the strait-jacket, lurches to his feet and runs over to the door. He tries to open it, but can't.

FARQUHAR: I don't think you're thinking this quite through. There's no way out there.

STYLER: *(Shouting.)* Help me somebody! Help me somebody, please!

FARQUHAR: There's nobody in the building who can help you. There's nobody in the building who'd want to help you. How about Borson? Why don't you ask Borson for help? I'm sure he'd be happy to oblige with a little mouth-to-mouth.

STYLER: Oh God!

STYLER sinks to his knees and tries to get out of the strait-jacket.

FARQUHAR: What are you doing?

STYLER: Let me go, please. Please, let me go.

FARQUHAR: You want to go?

STYLER: Yes!

FARQUHAR: But you've come all this way. You drove three and a half hours up the motorway just to see me.

STYLER: I came to see Dr Farquhar.

FARQUHAR: *(Pointing to the skeleton.)* There he is.

STYLER: *(Slumps to the floor, moaning.)* No…

FARQUHAR: This is very sad.

STYLER: Please don't hurt me!

FARQUHAR: *(Angry.)* Stop saying that! What do you think I am?

STYLER: I know what you are. I know what you are. You're…

FARQUHAR: Go on.

STYLER: Easterman.

FARQUHAR: Yes.

STYLER: You're going to kill me.

FARQUHAR: How do you know?

STYLER: You killed Nurse… Dr Ennis.

FARQUHAR: That was self-defence.

STYLER: *(Hysterical.)* Self defence? How can it…? What do you mean? Self-defence?

FARQUHAR: She hit me first. Do you want me to help you into a chair?

STYLER: No.

FARQUHAR: *(Approaching him.)* You'd be more comfortable…

STYLER: Keep away from me!

FARQUHAR: Have it your own way. *(Pause.)* Look. I didn't mean to kill her. But then of course, if I were responsible for my actions, I wouldn't be here, would I!

STYLER: Easterman…

FARQUHAR: Yes.

STYLER: Listen to me.

FARQUHAR: I'm all ears.

STYLER: *(Getting up.)* Take this off. Please. Take off this strait-jacket and let me go. I promise you, I won't tell anyone. Nobody needs to know I was ever here. Let me go and I'll go home and leave you to whatever it is you want to do. I promise.

FARQUHAR: You want me to let you go?

STYLER: Please.

FARQUHAR: And you won't tell anyone?

STYLER: I promise.

FARQUHAR: Do you think I'm mad? I mean, do you think I'm crazy? I let you go and you really just forget the whole thing happened?

STYLER: Yes!

FARQUHAR: No.

STYLER: Then what are you going to do with me?

FARQUHAR: What am I going to do with you? *(Pause.)* It's bizarre, isn't it. When I first saw you here in this room, I had no idea who you were. You see, it was three weeks ago that we took over Fairfields. Did she tell you...Dr Ennis?

STYLER: She told me. Yes.

FARQUHAR: It started right here in this office...just the three of us; Dr Ennis, Dr Farquhar and me. Oh – and Borson. He was part of it too. The psychodrama. You have no idea how much I used to dread those bloody sessions. The warm-up. The action. The journey through the spiral. It was so embarrassing! I mean, they wanted emotions. It all had to be out there. 'Why did you kill your father?' *(Another voice.)* 'My God! I didn't know I had killed my father!' *(Third voice.)* 'You did kill him and I should know because I am your father.' The whole thing was absurd – and since we've been talking about Laing I should say I use the word entirely in its non-existential sense. I can't help thinking that the world of psychiatry will be better

off without them. Doctors Ennis and Farquhar. What they were trying to do here was so obviously idiotic that only the most highly qualified and respected psychiatrists would be too stupid to see it.

STYLER: Was that why you killed them?

FARQUHAR: I killed them because the opportunity presented itself. We massacred the entire staff apart from one or two whom we kept for recreational purposes. I hope you noticed the 'whom' by the way. As my potential biographer, I'd like you to know that I'm a stickler for good grammar. Who and whom…you know the difference?

STYLER: Yes. Yes, of course.

FARQUHAR: Well, that's reassuring. Anyway, we butchered the staff, in every sense of the word where the good doctor was concerned. *(Gesturing at the skeleton.)*

STYLER: Don't remind me.

FARQUHAR: Why don't you sit down?

STYLER: No.

FARQUHAR: You'll feel better sitting down.

STYLER: No…

FARQUHAR: *(A scream.)* Sit down!

STYLER sits down. FARQUHAR continues his explanation as though nothing has happened.

FARQUHAR: Well, as soon as things had quietened down, I took over the running of Fairfields, working out of Dr Farquhar's office. My immediate concern was to make sure that what had happened here remained, at least for as long as possible, our own little secret…and that proved to be somewhat easier than I thought. We are, after all, in a very secluded corner of Suffolk, if indeed that most ill-defined of English counties can be said to have corners.

STYLER: I should never have come.

FARQUHAR: From the moment I saw you, all I wanted to do was get you to leave. I tried to make you go, but you wouldn't listen.

STYLER: I want to go now.

FARQUHAR: Of course you want to go now. But now I'm actually quite glad you've stayed. And you know what it was that changed my mind? *(Pause.)* Your book.

STYLER: Why?

FARQUHAR: Call it vanity. I'm impressed that you wanted to write about me. Not Borson. Or Morganstein. Or any of the rest of them. Me! I was flattered.

STYLER: I still want to write it.

FARQUHAR: Really?

STYLER: *(Grasping at straws.)* I can still write it. If you don't hurt me.

FARQUHAR: I would have thought you'd write with a great deal more conviction if I did hurt you. It would certainly help sales.

STYLER: No...

FARQUHAR: 'Mark Styler, best-selling author of "Serial Chiller" and its sequel, the even more fatuously titled "Bloodbath" was tortured by his next book, "Easterman, the Bath Killer" and quite literally so by its subject. This can be discerned from the growing incoherence of each chapter culminating in the short sentences of the final paragraphs written, it is believed, by the writer using a pen held in his toes, following the surgical removal all ten of his fingers...'

STYLER: Please...

STYLER sobs uncontrollably. FARQUHAR watches him.

FARQUHAR: I was only joking.

STYLER: What?

FARQUHAR: You're safe.

STYLER: Safe.

FARQUHAR: In my hands. But that's the point I'm trying to make right now. How safe would I be in yours?

STYLER: What?

FARQUHAR: If you were going to write a book about me, and perhaps you may still write a book about me, what would you put in it? That's what I want to know. I want to get inside your head, not because I'm interested in you – frankly, I'm not – but because I'm interested in just how and why you're interested in me.

STYLER: I was going to tell your story.

FARQUHAR: Yes. But my story according to who?

STYLER: You mean – 'to whom'.

FARQUHAR: *(Furious.)* Don't play the pedant with me, you little shit! *(Pause.)* You were going to write about what you thought of me, not what I am. Those are two quite separate things.

STYLER: I would have been fair.

FARQUHAR: Oh yes?

STYLER: Yes. I swear. I wanted to understand you, to know why you did…what you did. If you'd read my other books, you'd understand. I mean, look at Chikatilo. Even him. I tried to sympathise.

FARQUHAR: What was that title once again? 'The True Story of a Monster in the Ukraine.' That's not what I'd call sympathetic.

STYLER: That wasn't me. That was the publishers. They wanted the book to sell. They liked the word 'monster'. But I never thought that. I never used the word. Not once…

FARQUHAR: 'What was it that turned a golden boy into a revolting beast?' That was what you said. That's even worse!

STYLER: I said that?

FARQUHAR: Unless I misheard.

STYLER: Maybe you did.

FARQUHAR: I don't think so.

STYLER: I said it when I was trying to impress you, when you were Dr Farquhar. I didn't mean it.

FARQUHAR: So what did you mean? What were you going to say?

FARQUHAR picks up the scalpel and approaches STYLER who shies away.

FARQUHAR: You know, usually it's the biographer who pins down and then dissects his subject, but this time it could be the other way around.

STYLER: Don't.

FARQUHAR: But I'm giving you the opportunity to save yourself, Mr Styler. Tell me the truth. What you believe – not what you think I want to hear. Let's cut straight to the bone…

The scalpel is close to STYLER's face. STYLER moans. Then FARQUHAR whisks it away.

FARQUHAR: I want to know about you.

STYLER: What? What do you want to know?

FARQUHAR: Well, you could tell me what brought you here Why this interest in psychopaths?

STYLER: I told you…

FARQUHAR: You told me nothing. Oh you gave me some rubbish about the human condition but that's a bit like a crack-head pretending he takes cocaine because he's interested in the social history of Peru.

STYLER: If I tell you what you want to know, you'll let me leave?

FARQUHAR: If you tell me the truth, I might.

STYLER: I don't know. I don't know where to start.

FARQUHAR: How about with your mother? Don't most problems in life start with one's mother?

STYLER: No.

FARQUHAR: Victoria Barlow. That was her name, wasn't it. Now that's an interesting thought for you. You said you moved to London. Victoria Station. From one Victoria to another.

STYLER: I lived close to Victoria.

FARQUHAR: Were you close? You and your mum?

STYLER: You're not interested.

FARQUHAR: If I weren't interested, I wouldn't ask.

STYLER: Yes. We were close...

FARQUHAR: Victoria Barlow. I seem to remember her. Quite a large woman. Large teeth.

STYLER: Yes.

FARQUHAR: She lived at number twenty-nine. Twenty-nine Sunflower Court. She was my neighbour. And according to what you were telling me earlier, before you left her for the other Victoria, you lived with her.

STYLER: *(Uneasy.)* I was there some of the time.

FARQUHAR: Well, we must have run into each other. There was you living with your mother at number twenty-nine. There was me living with mine next door. You must have seen me.

STYLER: I wasn't there much of the time. I was at boarding school. Then university.

FARQUHAR: Which university?

STYLER: Does it matter?

FARQUHAR: Which university?

STYLER: Torquay.

FARQUHAR: There's a university in Torquay?

STYLER: Yes. *(Pause.)* It wasn't exactly a university. It was more of a college.

FARQUHAR: What was your subject?

STYLER: Catering.

FARQUHAR: It was a catering college.

STYLER: Yes.

FARQUHAR: You wanted to cook?

STYLER: No. But it was something to fall back on. A day-job...

FARQUHAR: While you were waiting to become a writer.

STYLER: Yes.

FARQUHAR: So you were away from home a lot.

STYLER: Most of the time.

FARQUHAR: But not all of it.

STYLER: No.

FARQUHAR: You must have come home to visit your mum.

STYLER: I did.

FARQUHAR: And you never saw me? On the other side of the garden wall?

STYLER: It was a fence. There was a wooden fence, covered in wisteria.

FARQUHAR: Yes. I remember it. *(Realising.)* 'My Mother's Garden' Did you write about the wisteria?

STYLER: Yes.

FARQUHAR: It was in your book. The wisteria between your garden and mine.

STYLER: I mentioned it.

FARQUHAR: Did your mother have any tips about the wisteria? I mean, it must have been growing pretty well anyway, considering all the nutrients I was putting into the soil.

STYLER: I can't remember.

FARQUHAR: There must have been something.

STYLER: Chinese wisteria grows anti-clockwise!

FARQUHAR: I'm sorry?

STYLER: My mother said that's how you tell the difference between Chinese and Japanese wisteria. The stems twine in different directions.

FARQUHAR: Is that all?

STYLER: That's all I can remember.

FARQUHAR: Well, I suppose in it's own way that's quite remarkable.

STYLER: She was.

FARQUHAR: And yet you never mentioned her, not after I told you who I was. And here you are, face-to-face with the man who killed her, but I don't sense any hatred. Maybe you've forgiven me. You said you were going to forgive me. Have you forgiven me?

A pause. STYLER says nothing.

FARQUHAR: Let's talk about this. This is intriguing. You and your mum. Why didn't you mention her earlier? In fact, now I come to think of it, why did you never say that for all those years…you and I actually lived next door?

STYLER: *(Faltering.)* Didn't I?

FARQUHAR: You didn't even say you'd lived in Bristol.

STYLER: I did.

FARQUHAR: You said you'd lived in the West Country but you were careful not to specify where.

STYLER: I didn't think it was relevant.

FARQUHAR: Of course it's relevant. We were neighbours.

STYLER: But I never saw you.

FARQUHAR: You're lying.

STYLER: No.

FARQUHAR: Yes. You saw me all the time. And how do I know? How do you think? Because I saw you!

A pause.

STYLER: Can I have a cigarette?

FARQUHAR: What?

STYLER: I want a cigarette.

FARQUHAR: You want me to give you a cigarette?

STYLER: Yes.

FARQUHAR: And how do you propose to smoke it?

A brief pause.

STYLER: You'll hold it for me.

FARQUHAR: You want me to hold a cigarette for you?

STYLER: Yes.

FARQUHAR: You don't think we're getting a little pally?

STYLER: I just want a cigarette.

FARQUHAR: All right.

FARQUHAR picks out the cigarette packet and takes one out. He examines it.

FARQUHAR: How strange.

STYLER: What now?

FARQUHAR: The packet says Embassy. But this cigarette is Lambert and Butler.

STYLER: Does it matter?

FARQUHAR: I'm just interested. Where did you get them?

STYLER: At a garage on the way up. I don't know.

FARQUHAR: That's very curious.

STYLER: Can I just have one?

FARQUHAR: Certainly.

FARQUHAR puts the cigarette between STYLER's lips. Then he gets the lighter out of the desk and stretches it on the chain. Throughout all this…

FARQUHAR: I used to see quite a lot of you. We should have recognised each other when you came in. I'm surprised we didn't. But then it has been thirty years.

FARQUHAR lights the cigarette.

FARQUHAR: You had a dog. A golden retriever. It used to bark to be let out. It's funny how the memories come flooding back. The two of you were always arguing.

STYLER: Me and the dog?

FARQUHAR: You and your mother. I used to hear you – over the fence.

STYLER: I told you. I wasn't there very much.

FARQUHAR: But when you were there, you argued.

STYLER: Sometimes.

FARQUHAR: What about?

STYLER: The usual things. My future.

FARQUHAR: She didn't think you had one, did she!

FARQUHAR offers the cigarette. STYLER takes a drag. FARQUHAR removes the cigarette from his lips for him.

STYLER: Thank you.

FARQUHAR: I wouldn't do this for just anyone, you know.

STYLER: Thank you very much.

FARQUHAR: You know, the more I think about it, the more I think you and your mother were at loggerheads.

STYLER: She was difficult. She was demanding.

FARQUHAR: You said she always encouraged you.

STYLER: Yes.

FARQUHAR: Yes, it's true?

STYLER: Yes, it's true that's what I said.

FARQUHAR: So she didn't encourage you.

STYLER: She was skeptical.

FARQUHAR: She didn't think you could write.

Another drag on the cigarette.

FARQUHAR: I'll tell you something. While we're in this climate of confidence.

STYLER: What?

FARQUHAR: I know where you're coming from.

STYLER: Do you?

FARQUHAR: I never got on with my mother either. She was always going on at me. A difficult, difficult woman. And one day, I just decided I'd had enough. And that was when I decapitated her.

STYLER: Why did you do it?

FARQUHAR: Why did I kill her?

STYLER: Her head…

FARQUHAR: I wrapped it in gift-wrap.

STYLER: Why did you do that?

FARQUHAR: It's a good question, Mark. And I'll tell you…I'll tell you why. You see. It was one of her habits. She always used to keep old gift-wrap. If you gave her a present she would unwrap it so carefully that it seemed to take for ever. You see, she didn't want the sellotape to tear the paper. And then she'd store the old paper in a kitchen drawer, to use it again when it was someone's birthday or she was invited to a dinner. And they always knew. Because no matter how careful she was, the paper was always a little crumpled. You could tell at once that it was second hand. And the funny thing was, no matter what she bought you, no matter how generous she was with the present itself, there was never any pleasure in it. There was never any pleasure in getting a present from her.

He gives STYLER another drag on the cigarette. STYLER chokes.

FARQUHAR: Shall I put this out?

STYLER nods. A pause. Then FARQUHAR suddenly grabs STYLER's head, clamping his hand over STYLER's mouth. He twists STYLER's head and begins to move the glowing cigarette towards STYLER's face.

FARQUHAR: You want me to put it out?

STYLER tries to scream, tries to beg, but the clamped hand cuts off almost all the sound. At the last minute, with the cigarette an inch away, FARQUHAR changes his mind. He drops the cigarette and grinds it out. Then lets STYLER go.

STYLER: *(Gasping.)* Why…? Why did you do that?

FARQUHAR: I didn't. I changed my mind.

STYLER: But you were going to.

FARQUHAR: Yes.

STYLER: Why?

FARQUHAR: *(A smile.)* Because I can.

STYLER: You're mad. You're evil.

FARQUHAR: Surely one or the other.

STYLER: What?

FARQUHAR: I can't be both. Come on, Mark. You're disappointing me. How could you have written a book about me with such sloppy thinking? Think about it for a minute. If I'm mad, then according to the Mental Health Act of 1983, I have a 'persistent disorder or disability of the mind.' In other words, I'm sick, I don't know what I'm doing.

STYLER: You know what you're doing.

FARQUHAR: So then I'm evil – which makes you wonder why I was considered unfit to stand trial and have spent the last thirty years in a hospital for the criminally insane. It's a paradox, isn't it. I wonder if it isn't possible that I'm something else, something neither mad nor evil but… something we don't understand.

STYLER: Why don't you just kill me? That's what you're going to do anyway.

FARQUHAR: Now you're being defeatist.

STYLER: I don't like these games.

FARQUHAR: Games? I'm not playing games, Mark. I'm trying to orientate myself into your scheme of things and at the same time, I hope, I'm slowly easing you into mine. Because it seems to me, and perhaps you won't disagree, that in some ways the two of us are very much alike.

STYLER: I'm nothing like you.

FARQUHAR: No? Why don't we consider the evidence?

FARQUHAR suddenly undoes one of the straps of the strait-jacket. STYLER reacts in surprise.

FARQUHAR: We began in the same place, you and I. Sunflower Court in Bristol, in the West Country. Your father died when you were young and so, by coincidence, did mine.

STYLER: You killed your father.

FARQUHAR: We lived on opposite sides of the garden fence. Both of us with our mothers. Isn't that strange? As I recall, we even looked quite similar you and I. Short hair, short trousers, short temper. We were like mirror images, the two of us, reflecting each other over the garden fence.

STYLER: I was nothing like you.

FARQUHAR: We shared the same interests.

STYLER: You were a serial killer.

FARQUHAR: And you wrote about killing! In fact you were obsessed by it. Two books on mass murderers and a third in the pipeline. Admit it and I'll undo another strap.

STYLER: I was interested.

FARQUHAR: Good enough.

FARQUHAR undoes a second strap.

FARQUHAR: You hated your mother as much as I hated mine. She had no faith in you. She never thought you'd amount to anything. You'd have loved to have killed her but you didn't dare do it in real life so you fantasized. You wrote books.

STYLER: No, no, no.

FARQUHAR: Yes. I've read 'Serial Chiller'. Dr Farquhar had it here in his desk and I picked it up and read it.

STYLER: You're lying.

FARQUHAR: It's the truth.

STYLER: Then where is it? Show it to me!

FARQUHAR: I lent it to Borson. He's enjoying it too. And we can both see that you didn't write it out of some sort of academic interest. You enjoyed it. The sadism, the grubby details. You reveled in them.

STYLER: No – that's just your sick mind.

FARQUHAR: Admit it, Mark. The last strap…

A pause.

STYLER: I enjoyed writing it. All writers enjoy their work.

FARQUHAR: It goes much further than that. You wrote it for the same reason that your readers would read it. For the same reason that people go to see this sort of stuff on the big screen. Because it arouses you. Your word not mine. Mirror images. We were then. We still are.

STYLER: No.

The third strap stays tied.

FARQUHAR: I'm trying to liberate you, Mark. Consider your situation. Here you are, completely in my power. I told you before that I was thinking of leaving the asylum. We all are. Midnight tonight and the whole lot of us are going to disappear. We were just making the last preparations when you arrived. It's all been a bit like the Colditz story, really, though without the sand down the trousers and the bonhomie. You could come with us. You could cross the

line and become an immortal, one of the golden few who look down on the world and who are for ever above it. You're never going to be Shakespeare or Dickens. You're not good enough. But how easy to become Chikatilo, Jack the Ripper, Easterman! You can prove Socrates wrong. You can be evil out of choice.

STYLER: *(Struggling.)* Set me free.

FARQUHAR: I don't need to. That's exactly the point. Right now you can tell me anything and everything. Nobody will ever know except you and me. We have this wonderful intimacy, Mark. The writer and his subject. The killer and the killed. Right now you can say things and do things you may have dreamed of all your life but have never dared to say or do because now, here, there are only the two of us and we can't even be sure which of us is mad.

A pause.

STYLER: I have nothing to hide.

FARQUHAR: Every man has something to hide. He couldn't be a man if he didn't.

FARQUHAR unties the third and final strap. A pause. STYLER runs for the nearest door and tries it. But the door is locked.

FARQUHAR: Oh don't do that. Don't be so facile. You can't run out on me. We have only this room.

STYLER: But you said you'd let me go.

FARQUHAR: I said you'd let yourself go. That's what I want.

STYLER: What?

FARQUHAR: Admit to me…

STYLER: That I admired you?

FARQUHAR: More. That you wanted to be me. That is what you wanted from the start.

A pause.

And then NURSE PAISLEY lunges out from behind the screen. Racked with pain, she crawls forward. Blood everywhere. STYLER can only glance in her direction in surprise. But FARQUHAR is delighted.

FARQUHAR: Well, well, well. There's a turn-up for the books. It seems that Dr Ennis has returned from the dead. *(He goes over to her.)* Can you hear me Dr Ennis? Are you still there?

PAISLEY: *(To STYLER.)* Help me.

FARQUHAR: *(To STYLER.)* She's ignoring me. She's talking to you.

PAISLEY: Please…

But STYLER doesn't move. He doesn't seem able to.

FARQUHAR: She wants you to help her. Do you want to help her? Or do you have this teeny weeny urge somewhere inside you to kill her?

A pause.

FARQUHAR: It all comes down to getting away with it. We keep on our masks, we conform, we follow the herd because we're afraid. But you don't have to be afraid any more. There are no consequences now. When the police do arrive – and even the Suffolk police have got to get here eventually – what are they going to think? It could have been me. It could have been anyone. But it couldn't possibly have been you.

STYLER: But…

FARQUHAR: What?

STYLER: She tried to help me.

FARQUHAR: She was pretty ineffectual. Here…

STYLER: No…

But FARQUHAR has scooped up PAISLEY and dragged her over to the hard-backed chair which positions her some distance from the desk. As he holds her, he calls to STYLER.

FARQUHAR: I think you'll find some adhesive tape on one of the drawers.

STYLER: What?

FARQUHAR: Top left. Do you think you could get it?

STYLER: Top left.

FARQUHAR: That's right.

STYLER takes out some industrial tape and hands it to FARQUHAR.
He binds it round PAISLEY, forcing her to sit upright in the chair
but keeping her legs free.

FARQUHAR: This is really just like the old times. We should
have met years ago, Mark. You and me at Sunflower Court.
Just think of all the fun we could have had.

PAISLEY: *(To STYLER.)* You can stop him. It's still not too late.

FARQUHAR: *(To PAISLEY.)* Of course it's too late. He's made
his choice.

FARQUHAR finishes with the tape.

FARQUHAR: So.

STYLER: What?

FARQUHAR: We've arrived at that moment. What do you want
to do?

STYLER: I…

FARQUHAR: You can do anything you want.

STYLER: I don't know.

FARQUHAR: You do know.

STYLER: No.

FARQUHAR: You're just afraid to admit it. *(Pause.)* You never
found the right woman. Is she the right woman? Well, she's
the only woman so we'll have to make do. But do you
want to kill her? That's the point. Look inside yourself and
answer this simple question. Do you have the urge to kill?

STYLER: Do I?

FARQUHAR: Do you. There's just you and me…

A pause.

STYLER: *(Quietly.)* Yes.

FARQUHAR: I'm sorry?

STYLER: *(Louder.)* Yes!

FARQUHAR: Yes, what?

STYLER: Yes, please.

FARQUHAR: You want to kill her.

STYLER: Yes. Yes, I do!

FARQUHAR: That's excellent. How do you want to kill her?
What would you enjoy?

STYLER is confused. He is a man who is beginning to lose his identity.

FARQUHAR: Your mother died with a knife driven into the
side of her throat.

STYLER: *(Still absorbing the truth.)* I could do that.

FARQUHAR: You could do that. You could have done that.
(Pause.) But you can't do that now because we don't have
a knife.

PAISLEY: *(To STYLER)* He's twisting you…

FARQUHAR: *(To PAISLEY)* Sssh!

PAISLEY: *(To STYLER.)* Please…

FARQUHAR: We do have a scalpel.

STYLER: No.

FARQUHAR: You're right. Too messy for a beginner. And the
blade…too small. I'd recommend a gun. That's easier. But
alas we have no gun. What does that leave us? There are
various drugs I suppose we could lay our hands on but…
Wait a minute. Wait a minute! We have fire.

PAISLEY: Don't listen to him. Don't let him do this.

FARQUHAR: Fire. What do you say to fire? It's easy. It's
dramatic. Maybe that would be the way to do it. You can
always close your eyes if it's too intense. *(Pause.)* Mark?

STYLER nods.

PAISLEY: No…

FARQUHAR: Let me see…

FARQUHAR goes over to the desk and rummages in the drawers.

FARQUHAR: Here…

FARQUHAR produces a can of lighter fuel. He hands it to STYLER.

FARQUHAR: Go for it, Mark. *(Pause.)* Go on…

STYLER hesitates, then sprays lighter fuel all over PAISLEY. She shudders in the chair.

FARQUHAR: You were talking about movies, Mark. Maybe we could sell this to Hollywood. Violence against women. Killing as entertainment. They'd love it. Easterman the Movie. Easterman vs Freddy Kruger. Scream Two, Artistic Integrity Nil. You'd be a star!

The stream of petrol ends. PAISLEY slumps in her chair. FARQUHAR goes to the desk and takes out the lighter on the chain.

FARQUHAR: So now we come to the moment of truth.

STYLER takes the lighter.

FARQUHAR: You can do it. You want to do it.

PAISLEY: No. He's twisting your mind. He's the devil, Mark. Don't listen to him.

STYLER: Shut up!

A pause.

STYLER: I want to do it. *(To FARQUHAR.)* Because I want to be like you.

FARQUHAR: Then do it.

STYLER strikes the lighter and advances on PAISLEY, with the chain stretching out.

PAISLEY: Please. Don't do this. You're not like him. This doesn't have to be your choice.

STYLER reaches the end of the chain. And he's not near enough to reach PAISLEY. He stands there, a couple of meters short, faintly ridiculous, the lighter in his hand.

FARQUHAR: Ah.

STYLER: It won't reach.

FARQUHAR: Clumsy. Slightly ludicrous, really.

STYLER: We…

FARQUHAR: What?

STYLER: We can move her.

FARQUHAR: Lift her up?

STYLER: We can do it together.

FARQUHAR: Together. All right. You take that side. Here we go then. One, two, three…

FARQUHAR and STYLER each take one side of the chair and lift up PAISLEY, setting her down nearer the desk.

FARQUHAR: There we are. That wasn't so bad. Now off you go again.

Once again STYLER picks up the lighter and approaches. This time he can reach. PAISLEY closes her eyes.

FARQUHAR: The moment of truth.

STYLER clicks the lighter. It doesn't light. He clicks it again. Nothing. A pause.

FARQUHAR: *(Irritated.)* What is it?

STYLER: It's out of fuel.

FARQUHAR: There's the fuel in the can.

STYLER: I used it all.

FARQUHAR: Is it my imagination or have we just taken a downward spiral into farce?

STYLER: I'm sorry. *(Pause.)* I still want to do it.

FARQUHAR: I think the moment has passed, really.

STYLER: Please.

FARQUHAR: Well, we'll have to consider another method.

STYLER: Yes.

FARQUHAR: You could strangle her.

STYLER: What?

FARQUHAR: I strangled two, maybe three of my victims. I forget the exact number.

STYLER: No.

FARQUHAR: Wait a minute…

FARQUHAR goes over to the desk and picks up the plastic Marks & Spencer bag. He takes the box of tissues out of the bag and hands the bag to STYLER.

FARQUHAR: Use this.

STYLER looks puzzled.

FARQUHAR: Use it to smother her.

STYLER: Smother her? With that?

FARQUHAR: Yes.

STYLER: It's Marks & Spencer.

FARQUHAR: That guarantees the quality. Put it over her head. She won't be able to breathe.

STYLER: I could do that.

FARQUHAR: Then do it.

PAISLEY: No…

FARQUHAR gives STYLER the bag.

FARQUHAR: This is getting tedious. Just do it and then let's go.

STYLER takes the bag and advances on PAISLEY.

PAISLEY: Mr Styler…you can't do this. I'll tell you why you can't do this. Because whatever he says, you're not like him. You're a rational person. You know what you're doing so it's impossible for you…

As quick as a flash, STYLER whips the bag over PAISLEY's head and holds it there. Tied to the chair, PAISLEY can barely struggle. But her legs kick out. Meanwhile, FARQUHAR gives advice.

FARQUHAR: That's right. Trap the ends and keep the air out but don't squeeze her throat. This is death by smothering, a Jacobean device frequently seen on stage. It's also the method, incidentally, by which Lee Marvin was killed in Stanley Donen's much-loved classic of 1963... *Charade.*

Suddenly PAISLEY slumps and her legs stop moving. Even then, STYLER doesn't relax his grip. Not until FARQUHAR comes over to him and lays a hand on his arm. And suddenly we are aware that FARQUHAR has changed character again. He's gentler now, rational, apologetic.

FARQUHAR: You've done it.

STYLER: Yes.

FARQUHAR: How did it feel?

STYLER: It felt...

FARQUHAR: Tell me!

STYLER: *(Sobbing.)* It felt horrible.

FARQUHAR: Because it <u>was</u> horrible. Do you feel remorse?

STYLER shakes his head, unable to speak.

FARQUHAR: Do you feel guilt? *(Pause.)* You feel disgust?

STYLER nods.

FARQUHAR: You wanted to be Easterman. *(Pause.)* You wanted to be Easterman.

STYLER: Yes.

FARQUHAR: And now you have become Easterman.

STYLER nods. Then realizes.

STYLER: No.

FARQUHAR: Ssssh!

STYLER: I'm not Easterman.

FARQUHAR: You are Easterman. But you don't want to be.

STYLER: No!

FARQUHAR: It's all right now. We've moved back to the periphery. We're in status nascendi. It's all right.

STYLER: What?

FARQUHAR: You are Easterman. You were always Easterman. But what we've explored a little more today is why you were Easterman.

A pause.

STYLER: What are you talking about?

FARQUHAR: *(Gently.)* Easterman…

STYLER: I'm Styler.

FARQUHAR: You were Styler. That's the name you chose. *(A smile.)* All Styler, no substance. He'd gone now.

STYLER: I'm a writer.

FARQUHAR: We have no more time now.

STYLER: What are you doing?

FARQUHAR: That's enough. Try and stay calm.

STYLER: This is a trick. You're trying to trick me.

FARQUHAR whips the bag off NURSE PAISLEY's head. She is alive. And she too has changed character. From now on she is a strong, business-like woman, totally in control. Unhappy about what has taken place.

It would seem that DR FARQUHAR is actually KAREL ENNIS.

NURSE PAISLEY is actally DR ALEX FARQUHAR.

And STYLER is actually EASTERMAN.

FARQUHAR: Tell him, Alex.

PAISLEY: Go back to your room, Easterman. That's enough for today.

A pause.

STYLER: *(To FARQUHAR.)* Dr Farquhar?

FARQUHAR: *(Indicating PAISLEY.)* This is Dr Farquhar.

STYLER: No.

FARQUHAR: *(To PAISLEY.)* I think you're going to have to help him.

PAISLEY: I'm Dr Farquhar.

STYLER: *(To FARQUHAR.)* So who are you? Who are you telling me…? Who are you?

FARQUHAR: I'm Karel Ennis. You know that. I'm your therapist.

STYLER: *(Close to tears)* No. You're doing this to me. You're both doing this to me.

PAISLEY: *(To FARQUHAR.)* Could you please let me out of this chair. I'd like to go and wash.

FARQUHAR: I'm sorry…

FARQUHAR picks up the scalpel and uses it to cut PAISLEY free. STYLER can only watch as she crosses to the desk and picks up the box of tissues, using one to wipe her face. Then she crosses to the second door and opens it. Not only is it unlocked but it also leads, this time, into a small bathroom with white tiles and a sink. During what follows, she washes and changes.

STYLER: What have you done to me?

FARQUHAR: You know where we've been travelling. You know what we talked about. The shifting anguish of responsibility.

STYLER: No. No. No. No. No. *(Pressing his fingers to his head.)* You're trying to take away who I am. I am Mark Styler. I'm a writer.

FARQUHAR: You tried to kill Nurse Paisley.

STYLER: *(With difficulty.)* I did it…because I was afraid of you.

FARQUHAR: You did it because you wanted to.

STYLER: No. I have written about murder. I have written…

A pause. FARQUHAR sees there is only one way forward.

FARQUHAR: It's over. You haven't written. There are no books.

STYLER: You had them. You lent them to Borson.

FARQUHAR: You came here in a red BMW. Where is the BMW?

STYLER: It's outside. It's by the main door.

FARQUHAR: Show me.

STYLER crosses to the window. The entire view has gone by now. A high brick wall surrounds the place.

STYLER: It's gone!

FARQUHAR: No. It was never there. You never drove to Suffolk. We're not in Suffolk. This is Victoria. This is the middle of London.

STYLER: But Fairfields.

FARQUHAR: That's what you like to call it. But there are no fields. You haven't seen a field in thirty years.

STYLER: It's a trick!

FARQUHAR picks a sheet of paper off the desk. It is the 'letter' that STYLER showed FARQUHAR when he first arrived.

FARQUHAR: This is the copy of the letter you sent me. You showed it to me. You said it was the letter you wrote to Dr Farquar.

STYLER: Yes.

FARQUHAR turns it round and now we see that it's a blank sheet of paper.

FARQUHAR: It's a blank sheet of paper.

STYLER: But you read it.

FARQUHAR: No. How could I? You read it to me.

STYLER: No…

FARQUHAR: Your tape recorder. The tape recorder you used when you were asking me questions…

FARQUHAR turns it round to show that it is broken, hollow, with no inner workings.

FARQUHAR: It has no tape. It has no batteries. It has no components. It's a shell. Just like Styler.

STYLER: You're saying that I'm mad and you're sane but that's not true. It's the other way round. You've taken over the asylum and you're doing this to me, both of you. You're doing this to me because you think you can get away with it. But I know who I am. I know what I am. I know…what I see…

STYLER sinks into a chair.

FARQUHAR: *(Gently.)* 'He does not think there is anything the matter with him because one of the things that is the matter with him is that he does not think there is anything the matter with him.'

PAISLEY walks back into the room. She has wiped off all the blood make-up and is now smartly dressed as the head of FAIRFIELDS.

PAISLEY: He's still here?

FARQUHAR: We're having a little trouble winding down.

PAISLEY: I'm not surprised. These sessions of yours, Karel, the psychodrama. It's getting out of hand.

FARQUHAR: So you've said.

PAISLEY: I sometimes wonder what it is exactly that you're trying to achieve. And I have to tell you, it's getting harder and harder to justify this to the board. Look at him, for heaven's sake! Sometimes I think your patients end up sicker than they were before you started…

FARQUHAR: …which is something you know perfectly well Moreno was accused of throughout his life…

PAISLEY: Yes.

FARQUHAR: …and which he cheerfully acknowledged. *(Quoting.)* 'I give them a small dose of insanity under conditions of control…'

STYLER: You're trying to make me mad.

FARQUHAR: 'You cannot control your emotions until you have fully experienced them.'

PAISLEY: Yes, yes, yes. But it's the nature of the experience that's beginning to worry me. And from my own

perspective, as head of this establishment and your boss – which perhaps I should remind you – I'm beginning to find these sessions…well, frankly humiliating.

FARQUHAR: *(Soothing.)* Alex…

PAISLEY: No! I haven't spent thirty years in clinical psychiatry to end up being a bit-player in the theatrical equivalent of a video nasty. And I'm growing increasingly concerned about the level of the violence.

FARQUHAR: There was no real violence.

PAISLEY: It was implicit.

STYLER is being ignored, edged out. And it's as if he can feel himself slipping away…his sanity slipping from him.

STYLER: No, no, no, no, no!

PAISLEY: Are you going to take him back to his room?

FARQUHAR: Of course. *(To STYLER.)* You need to rest. I know it's been exhausting for you, I know – but you should be pleased with yourself. You've made great progress.

STYLER: It's a lie. You're both lying.

PAISLEY sighs and picks up the telephone. Punches a number.

PAISLEY: *(Into the phone.)* Nurse Borson. Could you come up to my office, please.

She puts down the phone.

FARQUHAR: You realize this is the first time…it's the first time that he's acknowledged that there was a positive impulse, an actual desire to kill. That is to say, there was a rational choice.

STYLER: I'm Mark Styler.

FARQUHAR: That's real progress.

STYLER: I'm glad you agreed to see me.

PAISLEY: So it's a question of the means justifying the carpet.

FARQUHAR: I don't deny that.

STYLER: *(Looking up.)* What did you say?

PAISLEY: Come on, Karel. I'm as great an admirer of Moreno as you are. You know that. But I think you can envelope his methods to extremes.

STYLER: Carpet. Envelope.

FARQUHAR: But for ten years he had said nothing. He was nothing but wallpaper. And yet in the ten months since I started with him.

STYLER: It's a game.

PAISLEY: Cigarette?

FARQUHAR: No, thank you.

PAISLEY takes out a cigarette and lights it with a working lighter that is not attached to a chain.

PAISLEY: Jelly.

FARQUHAR: I wouldn't disagree.

PAISLEY: With the carpet or the wallpaper?

FARQUHAR: With either of them.

STYLER: I am…!

PAISLEY: Carpet. Envelope. And of course, wallpaper.

FARQUHAR: Cigarette. Jelly.

PAISLEY: Carpet. Envelope.

FARQUHAR: Wallpaper. Cigarette. Jelly.

PAISLEY: Carpet.

STYLER has shrunk into fetal position. He begins to rock back and forward, his hands pressed against his ears, his eyes closed, humming tunelessly to himself, trying to keep out the sight and the sound of the two people in the room.

FARQUHAR: Wallpaper. Wallpaper. Cigarette. Jelly.

PAISLEY: Carpet. Cigarette. Cigarette. Carpet.

FARQUHAR: Jelly. Carpet. Wallpaper. Cigarette. Envelope.

The words continue, spoken as if part of a completely rational conversation. And now they're echoing, a cacophony of sound. STYLER rocks back and forth.

The lights fade until he is left in a single spotlight.

Blackout.

The End

Endnote

The Mercury Theatre production used calming music throughout the play – the same music used in the film, 'One Flew Over the Cuckoo's Nest'. The music could be heard occasionally (and arbitrarily) through a speaker in FARQUHAR's study. It was also used as an ironic counterpoint to the murder at the end of Act One.

The play ended with FARQUHAR and PAISLEY both leaving the room, talking ('Envelope, carpet...') as they left. At the door, FARQUHAR paused and turned to STYLER.

FARQUHAR: Envelope.

As FARQUHAR closed the door, there was an echoing crash – a metal cell door – and STYLER fell to his knees. There was an instant light change. STYLER was now imprisoned in a square block of light with bars running across. FARQUHAR and PAISLEY could be heard walking away, their footsteps echoing on a metal floor.

The 'Cuckoo's Nest' music welled up. STYLER curled into a foetal position, humming vaguely to the tune.

Blackout.

WWW.OBERONBOOKS.COM

Follow us on www.twitter.com/@oberonbooks
& www.facebook.com/OberonBooksLondon

Printed in the USA
CPSIA information can be obtained
at www.ICGtesting.com
LVHW060024221024
794423LV00001B/4

* 9 7 8 1 8 4 0 0 2 1 7 3 8 *